THE DRAWINGS BY INIGO JONES, JOHN WEBB AND ISAAC DE CAUS AT WORCESTER COLLEGE OXFORD

CATALOGUE OF THE DRAWINGS BY INIGO JONES, JOHN WEBB AND ISAAC DE CAUS AT WORCESTER COLLEGE OXFORD

JOHN HARRIS AND A. A. TAIT

OXFORD
AT THE CLARENDON PRESS
1979

Oxford University Press, Walton Street, Oxford OX2 6DP

OXFORD LONDON GLASGOW
NEW YORK TORONTO MELBOURNE WELLINGTON
KUALA LUMPUR SINGAPORE JAKARTA HONG KONG TOKYO
DELHI BOMBAY CALCUTTA MADRAS KARACHI
NAIROBI DAR ES SALAAM CAPE TOWN

British Library Cataloguing in Publication Data
Worcester College
 Catalogue of the Inigo Jones drawings at
 Worcester College
 1. Jones, Inigo 2. Worcester College – Catalogs
 I. Title II. Harris, John, b. 1931
 III. Tait, A A
 720'.22'2 NA997.J7 78–40751
 ISBN 0–19–817362–8

*Printed in Great Britain
at the University Press, Oxford
by Eric Buckley
Printer to the University*

PREFACE

H. M. COLVIN's *Catalogue of Architectural Drawings of the 18th and 19th Centuries in the Library of Worcester College, Oxford*, which was published in 1964 to commemorate the two-hundred-and-fiftieth anniversary of the foundation of the College, is here followed by a catalogue of the College's greatest treasure, the drawings of Inigo Jones and John Webb (including the few by Isaac de Caus). We have decided for the sake of clarity not to adhere to J. A. Gotch's old numeration of the drawings. Designs for actual or intended buildings have been classified topographically. These are followed by a sequence of designs for unidentified buildings. Then at the end of the catalogue there is an appendix in which for the sake of completeness we list those drawings or designs that are continental, e.g. by Andrea Palladio and others. The theoretical section of this catalogue generally follows Gotch's numerical sequence, except where certain groups of drawings are more logically classified according to type. In general Webb's notes are given where they are either the only ones on the sheet, or, where there are several lengthy ones, the most typical.

Alas, we can only thank Dr R. A. Sayce posthumously, but to Miss Lesley Montgomery goes our gratitude for her patience with us on our many visits to the library; to Mr Howard Colvin and Sir John Summerson for advice and comments on several problems; to Mrs Margery Corbett for her entry on the *Polyglotta* title-page; but most of all we owe a considerable debt to Professor Per Palme who has generously provided very full information on the drawings for the Barber Surgeon's Anatomy Theatre, the College of Physicians, and Jones's designs for the Whitehall Cockpit and the Drury Lane Phoenix Theatres. Finally, and certainly not least, we and the publishers owe a debt of gratitude to the British Academy, to the Pilgrim Trust, and to Worcester College for their generous grants towards publication.

1978 J. H. A. A. T.

CONTENTS

PLATES

(AT END)

NOTE

THE catalogue is arranged in two sections: the first part deals with drawings which are connected, or apparently so, with a specific commission, while the second part is concerned with drawings which appear to have existed as an end in themselves—theoretical drawings. In the first section the drawings are grouped under architect and arranged alphabetically according to place; in the second they follow the order in which the drawings were arranged by J. A. Gotch and C. H. Wilkinson.

The drawings have been measured in centimetres and height is given before width. Where watermarks and countermarks occur, and where it has been possible to see them (for numerous drawings are glued to their backing sheet), this is indicated.

At each catalogue entry, the number given to the drawings by Gotch, or in the case of the Whitehall drawings by Whinney, is cited. There is thus a concordance between the catalogue numbers and their historical numeration.

HISTORY OF THE COLLECTION

JOHN HARRIS

WHEN Inigo Jones died in 1652 it was natural that his library and collection of drawings should pass to his faithful John Webb, who had laboured for so long in the shadow of his master. When Webb died in 1672 he instructed in his will[1] that his library and all his 'prints and Cutts and drawings of Architecture of what Nature or kindsoever' be left to his son William, with the proviso that nothing should be dispersed. It is not known if William had any interest in the collection, but such a proviso suggests that he did not, and must have been inserted as a means of protecting the collection from the inroads of acquisitive persons. Within about ten years a comment by John Aubrey hints that by c.1682 a substantial part of the collection had been dispersed. He observed that John Oliver, a city surveyor and Master Mason in the Office of Works, 'hath all Jones's plans and designs, not only of St Paul's Cathedral, etc., and the Banquetting House, but his designe of all Whitehall'.[2] This possession of Oliver's is now the Burlington–Devonshire Collection in the Royal Institute of British Architects.[3] Oliver died in 1701, but before then he may have relinquished his collection into the hands of William and John Talman. William Talman would have been a professional acquaintance, if not a friend. It is not known if Oliver also owned the designs by Palladio, which William Talman had also acquired before his death in 1719.

Following this event, John Talman sold two groups of drawings, by Jones and Palladio, to Lord Burlington.[4] Exactly what had remained in the possession of the Webb family after c.1682 is not known. The remainder might have passed to William Webb's younger brother James whose son John married Elizabeth Medlycott of Ven in Somerset, which family inherited the Webb family seat at Butleigh in the same county. However, by c.1705 at the latest, the bulk of Jones's library and a large group of drawings had been acquired by Dr George Clarke, who bequeathed them to the College in

[1] P.C.C. 145 EURE, dated 24 October 1672: 'keepe them intire together without selling or imbezzling any of them'.

[2] John Aubrey, *Brief Lives*, ed. Clarke (1898), ii. 10.

[3] For the Burlington–Devonshire Collection, cf. RIBA Burlington–Devonshire Collection (type-script 1960) handlist, and John Harris, *Catalogue of the Drawings Collection in the Royal Institute of British Architects. Inigo Jones and John Webb* (Farnborough, 1973).

[4] Graham and Collins Joynt Accounts: Chatsworth archives.

1734, although it is not certain if books and drawings were acquired simultaneously.[1] Clarke was using Jones's drawings as source material for designs made for the Warden's Lodge at All Souls by c.1703–5. Indeed, all through Clarke's numerous theoretical essays there are echoes of Jones's and Webb's designs. For example, for his design for the north quadrangle at All Souls, Clarke used Webb's 1648 Cobham elevation which is among the 'rolled' Whitehall designs. These 'rolls' could have been acquired separately, as were some of the books that Clarke possessed, such as the famous annotated Palladio bought in 1709. Clarke was a neo-Palladian *avant la lettre*, and because he consciously accumulated the remains of Jones's library and drawings, must be regarded as a significant figure in the history of the rise of interest in Jones and Palladio around 1710 when Wilbury was being designed by William Benson. The very name Wilbury is an epitome of this interest, for not only was the house modelled upon its neighbour, Amesbury (by Webb, but then thought to be by Jones), but its name combines the Wil- from Wilton and the -bury from Amesbury.

A. J. Cunningham, Librarian of Worcester College, could hardly have been aware of what his library contained, for when J. A. Gotch made his catalogue in 1913, published in the *RIBA Journal*, he was never shown all the drawings. This transpired when C. H. Wilkinson succeeded as Librarian in 1919, for he immediately wrote to Gotch on 3 March (RIBA archives), 'I find that you have recently been through the Inigo Jones drawings at this College and issued a catalogue both of them and those at Chatsworth. I regret—indeed I am afraid this letter must prove most annoying to you—that you have missed a very large number of Inigo Jones and Webb drawings in this library which were not in the big box and of whose existence no one else seems to have known, among which are some of great importance'. And so he goes on, no doubt to poor Gotch's mortification. Wilkinson apparently knew of them as an undergraduate and reveals that in 1919 they 'were getting into a very bad condition in odd portfolios etc.', and were quite separate from those that were kept in the 'big box'. Gotch hurried off to Oxford and compiled a 'supplementary' catalogue, but curiously this not only remained in manuscript,[2] but Gotch never made any capital out of this astonishing

[1] Much must have escaped from the collection at various times, e.g. Jones's annotated Vitruvius, now at Chatsworth, was owned by William Barry in 1714; Jones's annotated 1592 Serlio was presented by Michael Burghers to Queen's College, Oxford, where it now is. It was duplicated by Dr Clarke, whose copy is in Worcester College. Webb's annotated Serlio was owned by a 'Mr Churchill' c.1700 and is now in the RIBA; Jones's annotated Lomazzo was sold on the London market in the 1920s and is now in the possession of Mr Sidney Sabin; Webb's Scamozzi is among Dr Clarke's own architectural library at Worcester College, and was possibly a separate purchase; five drawings for Whitehall were in William Emmett's possession before 1714 and are now in the British Museum, where are also a number of Webb's stage designs (in the Lansdowne Collection). From Anthony Salvin came a group of designs that included three masque designs (now at Chatsworth), and some drawings by Webb. These are in the RIBA, and in the RIBA also is a single design by Jones for the Cotton tomb at Norton in Hales, Shropshire. This came from the Talman Collection.

[2] Manuscript in RIBA archives, copy with Worcester College.

discovery. As far as his *Inigo Jones* of 1928 was concerned they might never have existed. In 1922 Wilkinson described 'two great volumes in which all the loose drawings have recently been laid down',[1] so by then the two groups had been combined into the present volumes, and their arrangement must be due to Gotch and Wilkinson. It has frequently been assumed that the present order of the drawings follows some older classification. There is no evidence for this; indeed it is to the contrary.

A comparison between the collections at Worcester and the Royal Institute of British Architects shows that most of Jones's routine designs for the Office of Works are in the RIBA, whereas there are only three designs for Works commissions at Worcester College. The RIBA has a consistent group of theoretical designs for houses and palaces, all drawn by Webb, but although Worcester has many theoretical designs, they are for a variety of building types, as well as for the orders of architecture. The RIBA collection is therefore more concerned with the current running of an architectural office, and it is quite possible that these drawings were kept in the Works office, whilst those at Worcester are an accumulation from various sources, including the many designs by Isaac de Caus, which might have been in Jones's personal possession.

[1] C. H. Wilkinson, 'Worcester College Library', *Trans. Oxford Bibliographical Soc.* pt. I (1922–3; repr. 1927).

DESIGNS BY
INIGO JONES, JOHN WEBB
AND ISAAC DE CAUS
FOR BUILDINGS

JOHN HARRIS

INIGO JONES

LONDON: BARBER SURGEON'S ANATOMY THEATRE (Pls. 1–3)

Designs (2) in an unidentified hand and copies by Webb of designs by Jones.

1 (Gotch 1/7)
 Plan of ground floor and plan of first floor showing arrangement of seating around a dissecting table, and elevation of entrance front. Drawn by Webb. With scale.
 Insc.: (by Webb) *the Designe of ye Chirugians Theater* / 1636.
 Pen, incised lines, cross-hatching (457×355).
 Watermark.

2 (Gotch 1/7A)
 Plan of preliminary design and, verso, section of the design showing arrangement of seating, both drawn to a larger scale. With scale.
 Insc.: (in an unknown hand) *Theater of Anatomie.*
 Pencil and incised lines (483×571).

Lit.: John Harris, Stephen Orgel, and Roy Strong, *The King's Arcadia: Inigo Jones and The Stuart Court* (1973), p. 186 (hereafter referred to as *King's Arcadia*).

As Professor Per Palme has written, a 'publique Theater for Anatomycall exercises . . . ovally built' was petitioned for on 11 February 1636. A lease was granted on 5 May, and on 16 May it was ordered to be built 'according to the plotts drawne by his Ma's Surveigher'. On 3 August the Company's Arms were ordered to be set up 'in Portland Stone under the cantiliver dadoes of the Theater', and a long motto was to be cut 'over the greate doore into the Theater'. On 8 March 1637 an open gallery leading from the main Barber's Hall into the Theatre was ordered to be made into a 'faire Parlour'. Apart from ordering, on 24 July 1637, the painting of the Theatre's domed ceiling with the constellations and the planets, so ends the last building reference in the Court Minute Books. The Warden's Accounts itemize payments when Jones came to 'view the back ground' in 1635–6, and when the Court went to Jones 'about the Theater' in 1636–7. Payment was made to 'Mr. Mason that drew ye plots for ye Theater' in 1635–6, and to 'Mr. Wilson a mason to measure Stanley's worke in the Theater', and to 'Robert Butler and John Pullen for their measureing the Theater'. Nearly a century later the Theatre was restored at the expense of Lord Burlington (Minute Book 7 April 1730).

In 1736 or thereabouts (the generally agreed date for the first edition of *Designs of Inigo Jones and Others*) Isaac Ware published a plan and section of the Theatre, that must be, in view of Ware's intimacy with Burlington, the most authentic record of the Theatre as restored. Ware's engraving is valuable evidence for questioning the authenticity of Webb's drawing (no. 1), although not invalidating no. 2 which is clearly a preliminary design concentrating upon the amphitheatrical arrangements and interior communication. Neither the seventeenth-century drawings nor Ware's engraving satisfactorily explain how the Theatre was connected with the main building. Webb's plan of the second storey suggests a balcony above the Tuscan columns of the portico, linked to some form of bridge or open gallery, alluded to in the Minute Books. Possibly Jones designed a roofed walk at ground-floor level with access from the 'faire parlour' on to a balcony that led directly into the Theatre above the portico. The plans of nos. 1 and 2, and Ware's, do not diverge greatly in size. Number 2 recto is about 31 × 36 feet, Webb's is 30 × 40 feet, and Ware's 30 × 38 feet. Webb's elevation is difficult to reconcile with what is known of the exterior. He provides no indication of the long Latin inscription cut over the 'greate doore', nor of the cantilevered dadoes with the Company's Arms, and his upper range of windows is unaccountable unless they are blanks.

LONDON: MARQUESS OF BUCKINGHAM'S SECOND LODGING IN WHITEHALL PALACE (Pl. 4)

3 (Gotch unnumbered)
 Design for a ceiling, incorporating the arms of Lord Buckingham, and Villiers impaling Manners, for Katherine Manners, his wife.
 Plan and section through cornice.
 Insc.: *Fidei Coticula crux*.
 Pen, ink, and wash and water-colour (285 × 311).

Lit. and reprd.: Sir John Summerson, *Inigo Jones* (1966), p. 64, Pl. 25; *King's Arcadia*, pp. 121–2.

This is clearly only part of a design. It is hardly likely to have been drawn before 16 May 1620, for the middle shield has the arms of Villiers impaling Manners, a reference to the Marquess of Buckingham's marriage to Katherine Manners. Sir John Summerson has associated this design with work upon Buckingham's Second Lodging in Whitehall, which we know was somehow connected with his mother's Lodging adjacent to the King Street Gate. Buckingham's Lodging was being built in 1619–21. It was obviously a substantial building—a town house—with a brick façade. In that Lodging the Parliamentary Survey in 1650 mentions 'one large and Comely roome called the Dyninge Roome'. This must be the room whose 'roofe' (ceiling) was accounted for in the year

ending 30 September 1620 (PRO E. 351/3253): 'a roofe for a dyning roome for the Lord Marques of Buckingham his lodging' which had three windows each of two lights. The crown of the arch shown below Jones's design may well be one of these windows, and if so, then the room would have been six coffers or more wide, or probably ten (allowing for two coffers per window and two for each intermediary space) or even fourteen (allowing for two coffers' width at each end of the room). However, it is by no means certain that this design is for Whitehall. By 25 September 1622 Jones was involved in works for Buckingham at New Hall (then called East Beaulieu) in Essex, which included work on a gallery, armoury, stable, and chapel and hardly anything is known about the works carried out by Buckingham at his great house at Burley-on-the-Hill, Rutland.

LONDON: COCKPIT THEATRE, WHITEHALL (Pl. 5)

4 (Gotch 1/27)
Plan, plan of stage, and section through apron stage or proscenium, drawn by Webb.
 With scale.
 Pen and cross-hatching (356×457).
 Watermark.

Lit.: Mostly in G. E. Bentley, *The Jacobean and Caroline Stage*, vi (1968), pp. 267–88; also *King's Arcadia*, pp. 139–40.

Professor Per Palme has shown how the various interpretations of this drawing have complicated its elucidation from the earliest reference to it by W. R. Lethaby[1] to more recent accounts, e.g. Glynne Wickham,[2] and D. W. Rowan.[3] He shows how no authority has described the technical description of the drawing better than Hamilton Bell,[4] and that of W. W. Braines[5] was the first to quote the accounts of the Office of Works (PRO E. 351/3263/5–7) proving that Webb's drawing provides reliable evidence of the Cockpit-in-Court as reconstructed in 1629–31 according to the 'Designes and Draughts given by the Surveyor'. In 1932 Eleanore Boswell[6] published accounts from the Office of Works pertaining to repairs undertaken in 1660–3. Per Palme in his study of this drawing concluded that it was drawn after 1600 and that it should be classed with certain other so-called 'thesis' drawings that Webb made after the Restoration.

[1] 'Inigo Jones and the Theatre', *Architectural Review* (Apr. 1912), 189–90.
[2] 'The Cockpit Reconstructed', *New Theatre Magazine*, 7, no. 2 (Spring 1967), 26.
[3] *New Theatre Magazine*, 9, no. 3 (Summer 1969), 13.
[4] 'Contributions to the History of the English Playhouse', *Architectural Review*, xxxiii (New York, Mar. 1913), pt. I, 262–7.
[5] L.C.C., *Survey of London*, xiv (1931), pt. III, pp. 23–30.
[6] *The Restoration Court Stage* (1932), pp. 10–21, 239–41.

The compiler concurs with this view, grouping the Cockpit drawing with the Star Chamber and Barber Surgeon's, and the RIBA's York Water Gate, as later records, and to be associated as textbook endeavours, with projects for Whitehall Palace, excepting the P or preliminary scheme. The evidence to date the Cockpit drawing to the period of substantial repairs in 1660–2 was first pointed out by Hamilton Bell, who observed that the apron stage 'is surrounded on the three outward sides by a low railing of classic design about eighteen inches in height, just as in many Elizabethan Playhouses'— essentially a protective device to prevent incursions from the pit or yard. There are no references to rails in the Office of Works' accounts for 1628–42, but significantly in the accounts for 1660 (PRO Works, 5/1—printed in full by Eleanore Boswell, *The Restoration Court Stage*, p. 240) there is just such a reference: 'setting up of a rayle & Ballisters upon the stage . . .'. Per Palme has verbally pointed out that in early pictorial references to the Cockpit no chimneys are shown, whereas in the Danckerts view of Whitehall *c*.1674, two tall chimneys face the park. In Webb's plan a fireplace is shown in the left-hand corner of the lower tiring room behind the *frons scenae*. Again, there are no accounts for chimney-pieces in 1628–42, whereas in November 1662 bricklayers were paid for 'cutting way for 2 Chimneys & building them up at the Cockpit playhouse & mending tileing there' (PRO Works, 5/3).

LONDON: SIR PETER KILLIGREW'S HOUSE IN BLACKFRIARS (Pl. 6)

Drawing of the front *in situ* or copy of the design and details (3), drawn by Webb.

5 (Gotch 1/53C)
 Elevation.
 Insc.: (by Webb) *Sr Peter Killigrew in ye blackfryers | Mr Surveyors desygne.*
 Pen and pencil (204×305).
 Watermark.

Lit. and reprd.: Sir John Summerson, *Inigo Jones* (1966), pp. 113–14, Pl. 46.

Dated by Sir John Summerson to the late 1620s, here is a unique example of an Italian palazzo-style house in England, although the Italianism of the design is achieved by the experience of two earlier designs; the Prince's Lodging at Newmarket of 1619 (RIBA) and the design (Chatsworth) assigned to Sir Fulke Greville's house a little before 1619. Both the Greville and Maltravers designs are characterized by a strong horizontal cornice dividing the lower part of the façade from a windowed attic above. If this house was built—and there is no proof—it would be one of the rare examples of Jones designing for a courtier after 1625. *See also* nos. 181 O and R, 191 D, E, F.

LONDON: LORD MALTRAVERS'S DEVELOPMENT IN LOTH-BURY (Pls. 7–9)

Designs (3) for house and offices or warehouses.

6 (Gotch 1/55)
Elevation of a house. With scale.
Insc.: (by Jones) *uprighte for my lo Matravers | his house at Lothbury* 1638.
Pen and wash (400×310).
Watermark.

7 (Gotch 1/57)
Elevation for a house with a hexastyle portico. An attached flap shows amendments
to the balustraded tower and basement windows. With scale.
Pen and pencil (223×267).

8 (Gotch 1/58D)
Elevation for a row of terrace houses or warehouses of 152 feet frontage. With scale.
Pen (310×393).
Watermark.

Lit. and reprd.: Sir John Summerson, *Inigo Jones* (1966), p. 114, Pls. 47–8; *King's Arcadia*, p. 18.

Numbers 6 and 7 are associated by virtue of sharing a frontage of 55 feet. With skilful
proportioning of the added architectural embellishments Jones has visually enlarged
the 1638 design into something that looks like the miniaturizing of a grander design,
prophetic of the form of many a mid-Georgian country villa. Lord Maltravers, the
son of Lord Arundel, established an office in Lothbury for the minting of royal farthing
tokens. Number 8, associated with the other two in style and draughtsmanship, is
presented as a thirteen-bay terrace with two entrances, suggesting a commercial rather
than domestic use, and therefore perhaps related to Maltravers's projects. If this terrace
was built, then it is a direct source for Campbell's so-called innovating terrace of astylar
houses in Old Burlington Street.

LONDON: NEW EXCHANGE (ALIAS BRITAIN'S BURSE) IN THE STRAND (Pl. 10)

9 (Gotch 1/82)
Design for the arcaded front.
Elevation.
Insc.: verso (by Jones) *ffor ye new Exchange*, and repeated in pencil.
Ink, wash, and free-hand drawing (483×730).
Watermark.

Lit. and reprd.: Lawrence Stone, 'Inigo Jones and the New Exchange', *Archaeological Journal*, cxiv (1957), 106–21, Pl. XXIV; *King's Arcadia*, p. 30; Lawrence Stone, *Family and Fortune* (1973), pp. 96–109.

In 1606 Robert Cecil, Earl of Salisbury, had conceived a plan for developing an area west of Salisbury House. By the acquisition of land, especially a strip belonging to Durham House and fronting the Strand, Cecil was able to build an Exchange, complete by April 1609. This was supervised by Simon Basil who signed all the bills. Basil's building was drawn by John Smythson who visited London from 1618 to 1619, and although his drawing is certainly partly inaccurate, it is valuable in showing the advanced classicism of the design, relatable to almost contemporary work upon the south court front of Cecil's Hatfield designed in 1610 and regarded as an adolescent work by Jones. The mixed and very obvious bookish sources that go to make up Jones's design for the Exchange may not have been palatable to Cecil who seems to have steered a midway path between the reactionary camp and the new ideas being promulgated in the Court of Prince Henry. Nevertheless, Cecil was very ready to patronize Jones as a masque maker, and it is possible that some of Jones's ideas were incorporated in Basil's building. Whatever may be the grounds for doubting the veracity of all the elements in Smythson's drawing, one stands out as extraordinary: the semicircular arched window, for which no precedent can be found in England. It is surely highly significant that similar arched windows (with rustication) appear on no. 12, an early design for the Queen's House as well as in the incomplete Queen's House in Van Stalbempt's painting of King Charles and Queen Henrietta Maria in Greenwich Park (cf. John Harris, 'The Inigo Jones Exhibition', *Burl. Mag.* (Jan. 1974), 806–9). Cecil was also responsible for obtaining for Jones the commission for designing a new spire to Old St. Paul's Cathedral (no. 13), also in 1609. Jones draws upon similar sources for both the Exchange and St. Paul's drawings and both are in the extravagant romantic style of masque compositions.

LONDON: PHOENIX (OR COCKPIT) THEATRE IN DRURY LANE
(Pls. 11–12)

Designs (2)

10 (Gotch 1/7B)
 Plan and elevation.

11 (Gotch 1/7C)
 Two transverse sections. With scale.
 Pen and wash (324×430).
 Watermark.

Lit.: Dr D. F. Rowan, 'A Neglected Jones/Webb Theatre Project', *New Theatre Magazine*, vol. 9, no. 3 (1969), 6–16; *King's Arcadia*, pp. 107–8; Iain Mackintosh, 'Inigo Jones—Theatre Architect', *Tabs*, vol. 31, no. 3 (Sept. 1973), 99–105.

Both Professor Per Palme and Mr Iain Mackintosh have associated this project with the Phoenix (or Cockpit) Theatre in Drury Lane, opened in 1617 and managed by Christopher Beeston. Per Palme has now produced convincing proof that it is for the Phoenix and is publishing this separately. It is clear that Webb's *Siege of Rhodes* of 1666, performed in Rutland House, was on a stage modelled exactly upon the Phoenix one. These two designs are not only the oldest surviving theatre designs in England, but are of seminal importance for the development of the English stage. Mackintosh writes that in these designs 'Jones was as great an innovator in the planning of public theatres as he was in the Stuart Masques and that he pointed precisely the way the public playhouse would develop into the form it took after the Restoration of 1660'.

LONDON: QUEEN'S HOUSE AT GREENWICH (Pl. 13)

12 (Gotch 1/58J)
 Side (east or west) elevation.
 Pen, pencil, and ink (330×425)
 Watermark.

Lit. and reprd.: John Harris, 'The Greenwich Layout', *Architectural Review*, cxxvii (1960), 98–9; *King's Arcadia*, pp. 96–7; and for lit. only cf. M. Whinney, 'An Unknown Design for a Villa by Inigo Jones', *The Country Seat*, ed. H. M. Colvin and John Harris (1970), pp. 33–5; and John Harris, 'The Inigo Jones Exhibition', *Burl. Mag.* (Jan. 1974), 808–9, Figs. 75–6.

The compiler regards this drawing as a key document in the history of the Queen's House. Although the draughtsmanship has been questioned, there seems to be no doubt that the figures are by Jones. Therefore here is a design made in 1616 right at the beginning of his professional career, and one that fits in with the more idiosyncratic designs of the transitional period 1615–18. The rustications to the semicircular arched windows should be compared to the doorway of the 1616 design for an entrance façade in the RIBA (cf. John Harris, *Catalogue of the Drawings Collection of the Royal Institute of British Architects. Inigo Jones and John Webb* (Farnborough, 1973), nos. 73–4) and the type of plan that this elevation presupposes, with the plan copied by John Webb, also in the RIBA (Ibid., no. 206). The semicircular-headed window is a rarity for 1616, and significantly the only precedent appears to be the windows shown by Smythson on his drawings of the New Exchange (cf. no. 9). It is suggested by the compiler that the semicircular arched windows and doorway shown by Van Stalmbent in his painted view

of the incomplete Queen's House are in fact truthful records of what was originally built by Jones in 1616 and revised and rebuilt *c.*1630 (cf. John Harris, 'Inigo Jones and the Courtier Style', *Architectural Review* (July 1973)).

LONDON: ST. PAUL'S CATHEDRAL (Pl. 14)

13 (YC. 25)
 Design for the completion of the central tower of the old cathedral.
 Elevation.
 Pen, pencil, and wash (750×515).

Lit. and reprd.: Sir John Summerson, *Inigo Jones* (1964), p. 183, Pl. xxvIIa; and *Inigo Jones* (1966), pp. 27–8, Pl. 5; *King's Arcadia*, p. 31.

This curiosity, derivative from Palladio, Vignola, and Sangallo, resulted from a commission initiated in July 1608 when James I invited the Lord Mayor and Bishop of London to have the cathedral surveyed and a new spire designed. Robert Cecil was a member of this commission (St. Paul's 16/35), and he may well have persuaded his fellow commissioners to ask Jones for a design. The estimate for the works came to £22,527. 2s. 3d. (St. Paul's 16/37, no. 29), but nothing was proceeded with. This design and that for the Royal Exchange are precious evidence of Jones's adolescence in architecture. The British Vitruvius was not yet ready to face the world.

LONDON: ST. PAUL'S CATHEDRAL (Pl. 15)

14 (Gotch 1/46C)
 Design for the north transept front.
 Elevation with rough pencilled studies for volutes. With scale.
 Pencil and pen (596×445).
 Watermark.

Lit.: Sir John Summerson, *Inigo Jones* (1964), pp. 182–92.

This preliminary design was proposed for the third commission inaugurated (10 April 1631) by William Laud, Bishop of London, and successful from 1633 in the restoration of the old cathedral. The western parts, including the transepts, were virtually encased, and in Dugdale's *St. Paul's Cathedral* (1658) Hollar's engravings show what had been achieved by 1642 when works stopped. In general this transept design was carried out

for both transepts, but details such as the lower windows in the outer bays, the narrow windows in the projecting piers, and the form of the obelisks, are different. The centre part of this north transept was rebuilt in 1640.

LONDON: SOMERSET HOUSE (Pls. 16–18)

15 (Gotch 11/84)

Design, copied by Webb, but attributed to Jones, for an unidentified theatre, perhaps for Somerset House (on left-hand side of 249).

Plan of stage and elevation of *scena frons*.

Insc.: (by Webb) *And in ye designe | this Arch is in heigns | most two squares: | whereby ye length of | ye stage comes to bee | lesse that is here | drawne*, and verso: an inscription by Dr George Clarke (*see* no. 249).

Pen and ink (300 × 390).

Lit. and reprd.: W. Grant Keith, 'A Theatre Project by Inigo Jones', *Burl. Mag.* xxxi (1917), 61–70.

Grant Keith's article actually discusses a copy now identified by Mr H. M. Colvin as being drawn by Henry Aldrich. Grant Keith found this copy in Jones's annotated Palladio and he wrongly assumed it to be drawn by Jones. In 1917 he was not aware that in Worcester College was an undiscovered group of drawings supplementary to those already published by Gotch. Among them was the original, drawn by Webb. Both are now laid together as Gotch 11/84 and 84A. Per Palme and others have pointed out that this design lacks any apparent spectator entrance or exit, and Per Palme has made the suggestion that this design was for a temporary structure in an existing room. An obvious possibility is Somerset House. Jones had been commissioned many times to stage performances there, e.g. in 1626, 1630, 1633, 1634, and 1638. In particular, from October 1625 to September 1626 he was paid for making a large theatre in the upper end of the hall; or in 1633 a performance was enacted in the lower court. Although not necessarily associative, the Serlian street scene shown in the design is similar to the tragic scene that Orgel and Strong link with the performance of an unknown play in Somerset House 1629–30.[1] The area taken up by this design would be about 69 by 52 feet, much too large to have occupied the end of the Somerset House hall, but not for the lower court. *See also* Webb's drawings after the Teatro Olimpico, 249.

[1] S. Orgel and R. Strong, *Inigo Jones, The Theatre of the Stuart Court*, i (1973), pp. 397; and for accounts of performances in Somerset House cf. i, pp. 383, 389; and ii (1973), pp. 505, 725, 826.

LONDON: SOMERSET HOUSE

16A–D (Gotch 11/84A)
 Copy of 15 (Gotch 11/84).
 Pen and wash (355×390).

This copy has been identified by Mr Howard Colvin as Henry Aldrich's. It came from Jones's annotated Palladio, which book is known from inscriptions to have been acquired by Michael Burghers in April 1694 and from Burghers by Dr George Clarke in March 1708. In the Palladio the copy was inserted in the section dealing with theatres. The presence of an Aldrich drawing in the Palladio does not necessarily imply ownership of the book by Aldrich, for in any case the drawing is a copy of one by Webb in Clarke's collection from as early as *c.*1705. As Aldrich was, towards the end of his life, compiling his *Elementa Architecturae*, intended to be a comprehensive treatise on civil and military architecture, he would certainly have known of Clarke's acquisition of Jones's Palladio as well as the designs by Jones and Webb. He probably intended to publish his copy of the drawing in the theatre section of his *Elementa*. The drawing probably passed to Clarke when he acquired Aldrich's manuscript and drawings after Aldrich's death in 1710.

LONDON: SOMERSET HOUSE

Designs (3) or copies of designs for the palace wing fronting the Strand, drawn by Webb.

17 (Gotch 1/16)
 Elevation of half the Strand wing. First design.
 Insc.: (by Webb) *Upright of ye Pallace at So: Howse 1638 | Not taken.*
 Pen and wash (464×667).
 Watermark.

18 (Gotch 1/17)
 Plan (B) and elevation (A) of the Strand wing. Second design. With scale.
 Insc.: (by Webb) *Ground platt of ye Pallace at Somersett How: ye second Appartiment 1638* and *Upright of ye Pallace at So: Ho: ye second designe 1638.*
 Pen and cross-hatching (362×464).
 Watermark.

19 (Gotch 1/18)
 Two composite groupings (A and B) of doors and windows from the second design. With scale.
 Insc.: with notations, etc.
 Pen and cross-hatching (457×356).
 Watermark.

Lit.: *King's Arcadia*, p. 152.

What was intended here, but as far as is known never remotely under serious consideration, was a large palace with extensive mezzanine accommodation, intended as a monumental rebuilding of the Strand front, rationalizing the irregular old frontage, but tied in to the sixteenth-century courtyard plan. The drawings should be studied in relation to the P or preliminary project for Whitehall Palace, for in both cases the main block is based upon a design (now in the Devonshire Collection at Chatsworth) by Palladio encasing the Doges's Palace, Venice. The flanking parts of the front are taken from Serlio. It is instructive to compare Jones's use of Serlio with an anonymous architect's identical use of the source at Ashton Court, Somerset, Sir John Smyth's 1628 wing there. This comparison shows the division between Jones's primary Court style and the secondary style of the courtiers. Another drawing by Webb associated with no. 19 is RIBA 1/9[19] (cf. John Harris, *Catalogue of the Drawings Collection of the Royal Institute of British Architects. Inigo Jones and John Webb* (Farnborough, 1973), no. 50).

LONDON: STAR CHAMBER IN WESTMINSTER PALACE (Pls. 19–23)

Designs (2) and copies of designs (3) for a new Chamber.

20 (Gotch 1/1)
 Half-plan of ground floor, apse end.
 Insc.: verso (by Jones) *for the Modell of the | Star-chamber | 1617.*
 Pen, pencil, incised lines (535×425).
 Watermark.

21 (Gotch 1/2)
 Half-plan of entrance end.
 Pen, pencil, incised lines (535×430).
 Watermark.

22 (Gotch 1/3)
 Plan of the ground floor showing compartmentation of the ceiling. With scale. Drawn by Webb.
 Insc.: (in pencil in another hand) *Star Chamber.*
 Pen, pencil, incised lines (355×450).
 Watermark.

23 (Gotch 1/4)
 Elevation of the porticoed front. With scale. Drawn by Webb.
 Pen and pencil (355×450).
 Watermark.

24 (Gotch 1/5)
 Longitudinal section. With scale. Drawn by Webb.
 Pen and pencil (355×450).
 Watermark.

Lit. and reprd.: (22–4) Per Palme, *Triumph of Peace* (1956), pp. 183–91, Figs. 17–19;
Sir John Summerson, *Inigo Jones* (1966), pp. 48–9, Pls. 11–12; *King's Arcadia*, pp. 114–15.

The two dated designs by Jones can be related to a letter written by John Chamberlain
to Sir Dudley Carleton, 22 June 1617, stating, 'the King would fain have built' a
Star Chamber 'if there were money'. Alas, there was not. This roman basilical design
could be regarded as a trial run for the new Banqueting House. The elevations and
section are only known from these copies made by Webb in the late 1630s if not the
1640s. The design embodies elements from both Palladio and Scamozzi. It looks deriva-
tive, and one should certainly consider the possibility that Jones had seen designs by
Scamozzi then in Lord Arundel's collection, but now lost. Among the Whitehall
designs at Chatsworth (no. 68 verso; *King's Arcadia*, p. 114, no. 203) is a design for
combining a Star Chamber with a new debating chamber for a House of Commons.
Although this is inscribed by Webb 'for H of C', the compiler regards the free drawing-
in of the House of Commons part as possibly by Jones. It must be a project of the 1620s,
early rather than late, and would hardly have been seriously considered during the
long dissolution of Parliament between 1629 and 1640.

LONDON: WESTMINSTER ABBEY (Pls. 24–5)

Designs (2) for the catafalque of James I.

25 (Gotch, unnumbered)
 The catafalque in elevation, a domed temple set upon a platform. With scale.
 Pen and wash (610×430).

26 (Gotch, unnumbered)
 The dome and drum seen in perspective and to a larger scale.
 Pen and wash (310×430).

Lit.: Sir John Summerson, *Inigo Jones* (1966), p. 68, Pl. 69; *King's Arcadia*, p. 136.

James I died at Theobalds on 27 March 1625. The commissioners appointed by the new
king to expedite the funeral arrangements included the Earls of Pembroke and Arundel.
On 4 April the body was moved to Denmark House where it lay in state with a tem-
porary catafalque. It was not until 7 May that Jones's funeral hearse was ready in
Westminster Abbey. John Chamberlain wrote to Sir Dudley Carleton that it was 'the

fairest and best fashioned that hath ben seen'. Basically, Jones's design was carried out, but with certain variations. He shows a domed tempietto with pennants and shields and statues of virtues in mourning, whereas John Aubrey records being told by Emmanuel de Critz in 1649 that Jones 'made the 4 heades of cariarides (which bore up the canopie) of playster of Paris, and made the drapery of them of white callico, which was very handsome and very cheap, and shewed as well as if they had been cutt of white marble'. A possible explanation of this confliction may be that de Critz was confusing the temporary Denmark House catafalque with the Westminster one.

LONDON: WHITEHALL PALACE (Pl. 26)

27 (Gotch 1/6)
Design for the turret of a Clock House.
Elevation of clock with cupola shown above and behind a crenellated parapet, and verso, plan of the cupola. With scale.
Insc.: (by Jones) *June 1 1627 | for the clokehouse whighthale.*
Pen and wash (305×400).
Countermark.

Accounts (PRO E. 351/3260) for 1626–7 mention the erecting and decoration of a Clock House at Whitehall. The clock was three-sided, for which sides Robert Moore, carver, provided six Ionic capitals, and de Critz painted two dials, and on the third side 'a piece of Saturne devouring his children wth in a round'. It is by no means certain where this Clock House was. It has been suggested that the cupola was on the roof of the Great Chamber to the east side of the Preaching Place opposite the Banqueting House. However, surveys show the position of a Clock House on the north side of the northernmost court of Scotland Yard, and in Rocque's bird's-eye view of Westminster a cupola is indistinctly shown in this position.

LONDON: WHITEHALL PALACE (Pls. 27–37, 107)

Designs (28) and copies of designs for a new palace. Drawn by John Webb. Classified according to Dr Whinney's catalogue with a few new interpolations.

28 [P8 (Gotch II/17)] Elevations for river (above) and park fronts.
Pen and pencil (342×445).

29 [P21 (additional) (Gotch I/76)] Three sections (two through staircases) related to Whinney P4 (cruciform chapel on plan), P12, and P13; and the staircase in the angle of the plan, P20.
Insc.: (verso) (by Webb) *The scale is on the designe of ye uprights.*
Pen and pencil (320×410).

30 [K1 (Gotch II/1)] Plan at ground-floor level.
 Ink and grey wash (420×604).

31 [K1 (Gotch II/8)] C18 copy of II/1.

32 [K1 (Gotch II/10)] C19 copy of II/1.

33 [K2 (Gotch II/2)] Plan at first-floor level.
 Ink and grey wash (420×604).

34 [K2 (Gotch II/9)] C18 copy of II/2.

35 [K2 (Gotch II/11)] C19 copy of II/2.

36 [K3 (Gotch II/3)] Plan at second-floor level.
 Ink and grey wash (420×604).

37 [K6 (Gotch II/4)] Elevations of river (above) and park (below) fronts.
 Pen, pencil, and grey wash (342×445).

38 [K7 (Gotch III/1, roll 1)] Section through court from west to east (above), and
 elevation of north and south fronts (below).
 Ink and grey wash (440×940).

39 [K8 (Gotch II/5)] Sections from north to south.
 Ink, pencil, and grey wash (342×445).

40 [K9 (Gotch II/6)] Section showing court elevations.
 Ink, pencil, and grey wash (342×445).

41 [E1 (Gotch III/2, roll 2)] Section through court showing court elevations.
 Pen (440×1420).

42 [E2 (Gotch III/4, roll 4)] Elevation of river front.
 Pen (465×1370).

43 [E3 (Gotch III/5, roll 5)] Elevation for river front.
 Pen (465×1370).

44 [E4 (Gotch III/6, roll 6)] Elevation for north or south front.
 Pen (465×1370).

45 [E5 (Gotch III/7, roll 7)] Section from east to west.
 Pen (465×1370).

46 [E6 (Gotch III/8, roll 8)] Section from north to south.
 Pen (490×1320).

47 [E7 (Gotch III/9, roll 9)] Elevation for park front.
 Pen (465×1370).

48 [E8 (Gotch III/3, roll 3)] Cross-section for great court. Drawing cut out in outline
 and stuck on later paper.
 Pen and grey wash (390×1350).

49 [E9 (Gotch III/10, roll 10)] Elevation for park front. Drawing cut out in outline and
 stuck on later paper.
 Ink and grey wash (390×1350).

50 [E10 (Gotch III/11, roll 11)] Elevation for one of the short fronts. Drawing cut out
 in outline and stuck on later paper.
 Ink and grey wash (390×1350).

51 [E11 (Gotch III/12, roll 12)] Elevation for a long façade. Drawing cut out in outline
 and mounted on later paper.
 Ink and grey wash (490×1600).

52 [E12 (Gotch II/13, roll 13)] Cross-section through smaller courts.
 Ink and grey wash (490×1320).

53 [E13 (Gotch III/14, roll 14)] Elevation for a short front.
 Ink and grey and black washes (465×1580).

54 [E14 (Gotch II/28, numbered by Whinney III/15, roll 15)] Half-elevation.
 Insc.: (by Webb) *The Great Court opposite to ye Banqueting House.*
 Ink and brown wash (460×865).

55 [T2 (Gotch II/12)] Plan of the ground floor; verso: alterations to two central rooms.
 Insc.: *John Webb Archit:*
 Incised lines, brown ink wash, pencil, and pen (1020×740).

56 [Z2 (Gotch II/13)] Large-scale detail related to large elevation, Whinney Z1,
 Chatsworth 67.

In J. A. Gotch's biography of Jones (1928) the master's hand was noted as absent from
any surviving drawing and, in Gotch's eyes, Jones's responsibility for producing any
of the Whitehall designs rapidly diminished. In 1946 Dr Margaret Whinney reassessed
the drawings[1] and categorized them into seven schemes (P, K, C, E, T, D, S) produced
in five periods: *c.*1637–9 (P, K, C, E); 1647–8 (T); 1661 (D); and *c.*1661–5 (S). An
isolated drawing (Chatsworth 67) was lettered Z, and this Dr Whinney was not able
at the time to relate to Worcester College 56 (Gotch II/13), a larger-scale elevation of

 [1] M. Whinney, 'John Webb's drawings for Whitehall Palace', *Walpole Society*, xxxi (1946).

another part of the palace. More recently (1966) Sir John Summerson has scrutinized the designs anew and concludes that only one scheme (P), for a palace in St. James's Park, directly reflects Jones's style and ideas. The compiler of this catalogue agrees with Sir John. Jones's involvement in a new palace at Whitehall rests upon a statement by Sir William Sanderson in his *Compleat History of the Life and Raigne of King Charles* (1658), which connects the designs with the incident of the Londonderry Charter in 1638, and to a comment by Richard Daye in that year that 'His Majesty hath a desire to build Whitehall new again in a more uniform sort' (Whinney, p. 46). The only other scheme for Whitehall in Jones's lifetime can be dated to 1647, and this is the T or taken scheme, but it is almost certainly by Webb and Webb alone, although it is closely related to the P or preliminary scheme. All other schemes are also by Webb, sets D and S being produced for Charles II possibly as late as 1664 when the King showed John Evelyn plans for rebuilding. It can be seen therefore that Worcester College possesses two designs by Jones, drawn by Webb, an incomplete K scheme, published by William Kent in his *Designs of Inigo Jones and Others* (1727); all but two drawings for the E scheme; the earlier plan for the T scheme, related to a later plan and elevation at Chatsworth, and probably datable to 1647 but certainly not inscribed until after 1660; and Z2 which is a design for a palace at Whitehall, incorporating the Banqueting House, and so on the old palace site, but in a painterly hand that has so far eluded identification. This drawing may well be by a mason architect digesting a number of French and English Palladian elements.

NEWMARKET PALACE (Pls. 38–9)
57 (Gotch 1/58A)

> Design for a stable, possibly for Newmarket Palace.
> Elevation and, verso, transverse section.
> Pen and wash (470×355).
> Watermark.

Lit. and reprd.: John Harris, 'Inigo Jones and the Prince's Lodging at Newmarket', *Architectural History*, 2 (1959), 34, Pls. 6–7.

Although published as a drawing by Webb, the compiler now believes it to be an early (possibly *c.*1620) design by Jones. It need not be for the 'faire lardge newe stable for greate horse' (PRO E. 351/3251) accounted for at Newmarket in October 1617, for Jones also designed stables there in 1615–17 for Sir Thomas Compton and Mr Duppa, and stables at Theobalds Palace in 1623. See also 172.

WILTON HOUSE (WILTS.) (Pls. 40–8)

Designs (8) for ceilings.

58 (Gotch 1/8)
 The Great Stairs.
 Plan and two cove sections. With scale.
 Insc.: (by Jones) *Celing of the Great staire Wilton.*
 Pen and wash (355×480).

59 (Gotch 1/10)
 The Cabinet Room.
 Plan of ceiling and section of cove moulding. With scale.
 Insc.: (by Jones) *Ceeling of ye Cabbinett roome.*
 Pen and wash (355×480).

60 (Gotch, 1/11)
 The Cabinet Room, drawn or designed by Webb.
 Plan of ceiling, section of cove moulding, and details of decoration for the soffitt.
 With scale.
 Insc.: (by Webb) *ffor ye seeling in ye Cabinett roome | Wilton 1649.*
 Pen, pencil, and wash (355×480).

61 (Gotch 1/14)
 The Passage Room.
 Plan of ceiling and section of cove.
 Insc.: (by Jones) *Ceeling of ye passage roome | in to ye Garden.*
 Pen and wash (355×480).

62 (Gotch 1/9)
 The Countess of Pembroke's Bedchamber.
 Plan and section of moulding, with attached flap for modifications. With scale.
 Insc.: (by Jones) *Ceeling of ye countes of Pembrooke | bedchaber,* and (in pencil by
 Jones *Co: Pembroke.*
 Pen and wash (355×480).

63 (Gotch 1/13)
 The Countess of Carnarvon's Withdrawing Room.
 Plan of ceiling and section of cove moulding. With scale, some dimensions by Webb.
 Insc.: (by Jones) *Ceeling of ye countes of Carnarvons | withdrawing roome,* and (in
 pencil) *for ye Co: Carnarvons | withdrawing roome.*
 Pen and wash (355×480).

64 (Gotch 1/12)
 The Countess of Carnarvon's Bedchamber.
 Plan of ceiling and section of cove moulding. With scale.
 Insc.: (by Jones) *Ceeling of ye Countes of Carnarvons / bedchaber.*
 Pen and wash (362×483).

65 (Gotch 1/15)
 Design for a ceiling of nine compartments, drawn by an anonymous hand.
 Plan of ceiling, and verso, pencil studies for variant treatment of the compartments.
 With scale.
 Pen, pencil, and wash (300×482).

There are three possible periods in which to date these designs: (*a*) before the 1630s
in the old house, and for William, third Earl of Pembroke, who died in 1630; or (*b*)
for the interiors of the south front as decorated in the late 1630s for the fourth Earl;
or (*c*) c.1649 for the rehabilitation of the south front rooms after the fire, when Webb
was in charge for the fourth and fifth Earls. The seven identified designs are for six
rooms and clearly survive from a larger group, now broken up. For example, the Count-
ess of Pembroke would have had her Withdrawing Room new ceiled, and there would
have been other ceiling designs for more important state rooms. It is therefore hazardous
to assume that because the Earl of Carnarvon (Lord Pembroke's son-in-law) is not
mentioned, the designs were made after his death in September 1643. Webb's responsi-
bility for the state rooms after 1648 is a documented fact. His ceilings are styled some-
what differently from Jones's (cf. the two cabinet room designs). This, together with
the fifth Earl's known dislike of Jones (whom he called 'iniquity Jones'), lessens the
possibility that Jones, in his old age, offered a set of post-fire ceiling designs that were
rejected. Did he, therefore, propose them for the de Caus house between about 1638 and
1640? In the compiler's opinion it would seem strange that Jones should have been
recorded as having rejected the joint request of the King and the fourth Earl to design
the south front, on the grounds of pressure of business at Greenwich, and yet be pre-
pared to design interiors, a more time-consuming task. Perhaps, therefore, these ceilings
were proposed for the third Earl, who was Jones's intimate friend, for rooms in the
Tudor house. This would make more sense stylistically. A variant design by Webb
for the Cabinet Room ceiling is Ashmolean Cotelle Album, folio 89A.

UNIDENTIFIED DESIGNS

66 (Gotch 11/92)
 Design for a tempietto raised on a base or stand (Pl. 49).
 Plan and elevation. With scale.
 Ink and grey wash (270×320).

67 (Gotch 11/93)

 Design for a tempietto raised upon a base or stand (Pl. 50).

 Plan and elevation. With scale.

 Ink (270×320).

Both these related designs are early drawings by Jones (e.g. note the flag only used on drawings before *c.*1620), and if the scale is a foot one, the tempietto stands 14 feet 6 inches to the top of the dome. It is possibly part of a processional decoration or masque, and is worth comparing with the tempietto in Ben Jonson's masque *King Oberon* performed 1 January 1611 for Prince Henry (cf. P. Simpson and C. F. Bell, 'Designs by Inigo Jones for masques at court', *Walpole Soc.* xii (1924), 44–6).

68 (Gotch 1/55A)

 Elevation of a seven-bay house, the windows grouped two-three-two, with a 'pergula' to the three middle bays which are terminated by a pedimented concave gable (Pl. 51). With scale.

 Pen and wash (172×197).

Lit.: *King's Arcadia*, p. 111.

This design is for a 76-foot front. The 'pergular', pedimented gable, and dropped lintel (similar to one at Raynham Hall *c.*1622) classify this design as an early one in the transitional phase of Jones's career, *c.*1615–*c.*1618.

69 (Gotch 1/58C)

 Elevation of a pair of two houses with voussoired entrances, balustraded central windows, and above a heavy unbroken cornice, arched and circular windows, and triangular pediments, redrawn from segmental ones (Pl. 52).

 Pen, wash, and pencil (431×280).

Lit.: John Harris, 'Inigo Jones and the Courtier Style', *Architectural Review* (July 1973), 20, Figs. 19–21.

This is almost certainly an early design before 1617. It can instructively be compared to the 'Newe' building at St. James's Palace drawn by John Smythson in 1618 (RIBA) and to Boston Manor, Middlesex, a house with very advanced parts built from 1622, if not designed earlier. All three buildings have in common the heavy cornice above which are gables with arched openings in them. Boston Manor is of the type that is sometimes termed subordinate in style, closer to the taste of the courtiers rather than the purer Italianism imposed by Jones upon works designed by him for the King. This design, and nos. 68 and 70, are of a type that suggests the possibility of Jones having

visited Augsburg, as a diversion from Strasbourg, in 1613, when he would have seen
the buildings designed by Holl and Heins and even studied their drawings at first hand.
As a painter/architect Heins has much to commend a comparison with Jones, and his
Metzg of 1609 is very close to the style of these early or transition designs of Jones's
adolescence in the *Works*.

70 (Gotch, unnumbered)
 Design for a town façade with a two-bay voussoired arcade on the ground floor,
 a Palladian window in the first floor, a heavy unbroken cornice above, and a win-
 dowed attic (Pl. 53).
 Elevation.
 Black chalk and pen (310×203).

This should be seen as a culmination in the development of Jones's idiom for street
façades. His earliest is probably HT 191 or the Chatsworth design for Fulke Greville's
House (*King's Arcadia*, p. 105); an intermediate design may be the sketch elevation and
plan found on the verso of a Masque of Augurs's drawing c.1622 (S. Orgel and R.
Strong, *Inigo Jones, The Theatre of the Stuart Court*, i (1973), no. 117 verso). In this latest
design the idiom is Palladian rather than Northern.

71 (Gotch 1/53B)
 Design for an architecturally unified group of shops with arcades (Pl. 54). With scale.
 Elevation, drawn by Webb.
 Pen and wash (324×420).
 Watermark.

This must be a design by Jones (although the authorship of the drawing is uncertain)
and it fits stylistically with the Covent Garden development of the 1630s. It may be the
building referred to in Ben Jonson's poem 'To Inigo Marquess Would be A Corollary'
(*Ben Jonson*, ed. C. H. Herford Percy and Evelyn Simpson, viii (Oxford, 1947),
pp. 406–7). The relevant lines are: 'He may have skill & judgement to designe / Cittyes
& Temples! thou a Cave for Wyne, / Or Ale! He build a pallace! Thou a shopp /
W^th slyding windowes, & false Lights a top!' The frontage proposed by Jones measures
57 feet. Jones would have known Bramante's House by Raphael (he owned the 'Palladio'
view of it), or the Palazzo Alberoni, also in Rome. The design should also be compared
to Webb's theoretical design for a house (RIBA BD V/5).

BOX OF HEADS (Pl. 127, no. 1)

72 (Gotch, unnumbered)

This contains 18 matts of 116 drawings, the most important surviving group of figure studies outside those at Chatsworth. Indeed, a study of the Worcester and Chatsworth drawings would be inseparable. In essence Jones's interests are concentrated upon Mannerist engravings, particularly those by Agostino Carraci, Bandinelli, and especially Parmigianino. A few of the Worcester drawings are portraits, e.g. 12D and 12F, and two (6E and 6F) may be designs for statues upon pedestals. The quintessence of Jones's love for Parmigianino is contained in the fourth Earl of Pembroke's remark in his volume of Parmigianesque engravings, 'Inigo Jones so fond of Parmigianino, that he bought the Prints of the Imperfect Plates, which are no(t) here in this Book' (Wilton Album, Metropolitan Museum of Art, New York). For an account of the Chatsworth sketchbook see Jean Sumner Smith, 'The Italian Sources of Inigo Jones's Style', *Burl. Mag.* (July 1952), 200–7.

JOHN WEBB

COBHAM HALL (KENT) (Pl. 55)

73 (Gotch 11/29)
 Design for rebuilding.
 East–west section showing elevation of the south front to the south court, section through the Great Hall in the cross-wing, elevations of south front to the second court, and section through the west wing of the second court. With scale.
 Insc.: *Purfyle of ye Dukes Pallace at Cobham 1648.*
 Pen and wash (410×920).

Lit.: *King's Arcadia*, p. 205.

This project, commissioned by James, fourth Duke of Lenox and Richmond, was for the Palladianizing of the great Elizabethan house upon its old plan. As 1648 was a dread year in any Royalist's fortunes, it is not surprising that this project was abortive. Here, as in the Durham House projects, Webb can be seen breaking away from the style of his master, to create a manner of baroque classicism, demonstrably a style of his own and one to be fulfilled at Greenwich in the Charles II block.

HALE PARK (HANTS) (Pl. 56)

74 (Gotch 1/53)
 Design for a hunting-lodge or small house.
 Plan, and rough studies of plans, and elevation. With scale.
 Insc.: (by Webb) adjacent to one plan, *before a loggia | above | behind a loggia below.*
 Pen, pencil, and wash with body colour added (394×515).
 Watermark.

This design is a companion to two others in the RIBA, one dated 1638 and inscribed for *Mr Penruddock 1638 for a Lodge in a park in Hampshire*. The designs must have been commissioned following the death in 1637 of Thomas Penruddock at Hale Park, and the succession of his son John. Thomas had been closely involved with Jones, for Hale Church, begun in 1631, is so closely modelled after parts of St. Paul's Covent Garden, that it could be by no other. The Worcester design is closest to RIBA BD IV/5[1]. The three designs propose a building of varying sizes if the scales are to be relied upon: the RIBA designs proposing fronts of 42 and 49 feet, whereas this Worcester design is scaled to 52 feet. The reference to a *Lodge in a park* suggests a nearby hunting-lodge.

Although Sir John Summerson regards this Hale design as by Jones and a countrified version of the Queen's House, the compiler believes that the existence of these three designs all drawn by Webb and showing various tentative stages of development, points to Webb's complete control and Hale may therefore be among his earliest designs worked out unsupervised by the master.

LONDON: COLLEGE OF PHYSICIANS (Pls. 57–62)

Designs (6) for Library, Repository, and Consulting Room.

75 (Gotch 1/58L)
Elevation of pilastered front. With scale.
Insc.: (by Webb) *The ffront Jo: Webb*, and verso with measurements.
Pen, pencil, and wash (394×521).
Watermark.

76 (Gotch 1/58M)
Longitudinal section showing wall elevations of Library and Repository. With scale.
Insc.: (by Webb) *The Inside of the Library & Repository / Jo: Webb.*
Pen and wash (394×521).
Watermark.

77 (Gotch 1/58N)
Transverse sections. With scale.
Insc.: (by Webb) *The End of the Library* and *The End of the Repository / Jo: Webb.*
Pen and wash (394×521).
Watermark.

78 (Gotch 1/25)
Plan (A) and elevation of end wall of Library (B). With scale.
Insc.: (by Webb) *The Plant of the Library Phisitions Colledge 1651 / Jo: Webb,* and *The End of ye Library,* and verso: *The Library Phisitions Colledge / 1651 Not taken.*
Pen and wash (439×578).
Watermark.

79 (Gotch 1/26)
Two longitudinal wall elevations of Library (A, B).
Insc.: (by Webb) *The Syde of ye Librery at Phisitions Colledge next ye wyndowes* and *The Syde of ye Librery opposite to ye wyndowes,* and *Jo: Webb.*
Pen and wash (445×570).
Watermark.

80 (Gotch 1/24)
Three wall elevations (A, B, C) for a Consulting Room; with flap over chimney-piece for modifications. With scale.

Insc.: (by Webb) *Wainscott for ye Consultation roome at Phisitions Colledge*, and *Jo: Webb s.* twice, verso: *Wainscott & moulds for ye Consultation roome at Phisitions Colledge 1651* and *Not Taken*.
Pen and wash (439×578).
Watermark.

Lit.: C. E. Newman, 'The First Library of the Royal College of Physicians', *Journal of the Royal College of Physicians, London*, vol. 3, no. 3 (Apr. 1969).

The very first entry in the Latin *Annales* of the College occurs under the date 4 July 1651 when the following statement was read by Dr Prujean, the President of the College: 'If I can procure one, that will build us a Library, and a Repository for Simples and Rarities, such a one shall be suitable and honorable to the College; will ye assent to haue it done or no, and giue me leaue and such others as I shall desire to be the designers and overlookers of the worke, both for conveniency and ornament?' Dr George Clark[1] is right in assuming that Dr Prujean was, in fact, reading aloud from a letter from William Harvey, who as yet wanted to remain anonymous. Harvey, as a close friend of Jones, must certainly have had the aged architect in mind as the designer, and, as Per Palme has suggested, may have commissioned Jones for the rotunda drawing in the Burlington–Devonshire Collection.[2] Work was begun upon the site at Amen Corner in 1652 and Harvey's name was inscribed on the exterior in 1653. In addition to the Library and Repository for medical herbs and rarities, the building also contained an assembly hall for solemn *Comitia*, as well as a parlour for informal meetings and consultations. Only one description of the building before its destruction in 1666 has survived. In the *Minutes for Lives* John Aubrey writes 'Dr Harvey added (or was very bountifull in contributing to) a noble building of Roman Architecture (of Rustique worke with Corinthian pillasters) at the Physitians' College aforesaid, viz. a great parlour (a kind of Convocation house) for the Fellowes to meet in belowe; and a Library above. On the outside on the Freeze in letters 3 inches long is this inscription: SUASA ET CURA FRAN. PRUJEANI PRAESIDIS ET EDMUNDI SMITH INCHOATA ET PERFECTA EST HAEC FRABRICA. AN. MI CLIII. All these Remembrances & Building was destroyed by the generall fire.' John Evelyn adds the interesting information (Diary, 3 October 1662) that there was also in the College a 'theatre for anatomy'. The problem as to where this Theatre was remains unresolved; but Per Palme assumes that the Court Room was used for this purpose. In general, but not in particular, the designs by Webb must be assumed to reflect fairly faithfully the interior disposition of the College. In the Chatsworth *Book of Capitals*, 17–19 (RIBA loan deposit), are capitals for *ye ffront, The Library*, and *The Repository*.

[1] *History of the Royal College of Physicians of London*, i (1964), pp. 285–6, 298–9.
[2] Cf. John Harris, *Drawings by Inigo Jones and John Webb in the Royal Institute of British Architects* (1973), p. 13, cat. no. 13.

LONDON: DURHAM HOUSE IN THE STRAND (Pls. 63–8)

Designs (6) for first, second, and third designs; the smaller design; and two sheets of notations.

81 (Gotch 1/21)
 Elevation of Strand front, first design. Attached flaps with modifications to attic windows.
 Insc.: (by Webb) *not taken Durham Howse.*
 Pen and wash (362×458).
 Watermark.

82 (Gotch 1/19)
 Plan of the ground floor, second design.
 Insc.: (by Webb) *Ground platt Durham Howse 2: designe.*
 Pen and wash (355×458).
 Watermark.

83 (Gotch 1/20)
 Plan of the main floor, second design.
 Insc.: (by Webb) *Second ffloor Durham howse. not taken | 2: Designe,* and, verso, *Second designe Durham howse | not taken.*
 Pen and wash (355×458).
 Watermark.

84 (Gotch 1/22)
 Plan of ground floor, third design. With scale.
 Insc.: (by Webb) *Ground platt for Durham howse 1649 Not taken | The 3rd designe,* and *Garden towards ye Thames,* and, verso, *This designe for Durham | howse taken* (*taken* crossed out) *not taken,* and with many calculations.
 Pen and wash (356×451).
 Watermark.

85 (Gotch 1/23)
 Plan of main floor, third design. With scale.
 Insc.: (by Webb) *Plant of ye Second Storey for Durham house not* (the *not* inserted above as afterthought) *taken.*
 Pen and wash (355×458).
 Watermark.

86 (Gotch 1/52A)
 Elevation of the smaller design. With scale.
 Insc.: verso (by Webb) *For ye Earle of Pembroke in Durham Yard* and s. *Jo: Webb.*
 Pen and wash (445×572).
 Watermark.

87–8 (Gotch 11/78 17)

 Sheet of notations and calculations, one referring to '*ye 2 designe taken*' (87), the other
(88) referring to a loggia.

In 1641 Philip Herbert, fourth Earl of Pembroke, obtained Durham House. His sub-
sequent expensive involvement at Wilton lessens the probability that these grandilo-
quent projects were ever seriously contemplated. The more stereotyped Palladian
character (a fairly literal translation from a design published by Scamozzi in 1615)
of the smaller design was most likely proposed between 1641 and 1649 when the Earl
died. It is indeed possible that the *not taken* projects were commissioned for Philip, the
fifth Earl, for one is dated 1649 and the fourth Earl had died on 23 January 1650 (still
1649 in the old calendar). These designs are pedestrian in their boring horizontal
accents, but are notable for Webb's use of the giant order prophetic of his handling of
the order at Greenwich Palace in 1661.

LONDON: GREENWICH PALACE (Pls. 69–70)

89 (Gotch 11/97)

 Design for a palace for Charles II.

 Plan of the main floor proposing the two river wings joined by an east–west cross-
wing a single room in width, with an attached flap showing the cross-wing amplified
in width and with a domed central pavilion.

 Insc.: (in an unknown hand) *Greenwich House* and (in pencil, in yet another hand)
Greenwich House.

 Pen and wash (673 × 470).

 Watermark.

This is the preliminary plan, proffered in 1662. An associated plan with elevations to
the amplified cross-wing version is in All Souls College (v, 21, 25–6). The RIBA plan
(BD III/1$^1$) is slightly later in date, but has similarly the chapel projecting from the
centre of the east wing. Work at Greenwich was begun upon the west wing (now
known as the Charles II block) in March 1664, but by 1668 completion of the external
fabric of this wing and the utilitarian fitting-out of its interior put an end to Webb's
dreams of a resplendent palace on the Thames.

LONDON: GREENWICH PALACE (Pl. 71)

90 (Gotch 1/31)
 Design for a fountain by an anonymous French designer in Queen Henrietta Maria's employ. With scale (in *pieds*, written by the Frenchman).
 Insc.: (by Webb) *For a ffountaine in a wall at Greenwich 1637.*
 Pen and wash (394×260).

Reprd.: G. H. Chettle, *The Queen's House* (1937), fig. 7; *King's Arcadia*, p. 156.

91 (Gotch 1/31A)
 Redrawing by Webb of the anonymous design for a fountain (Pl. 72).
 Elevation with a caryatid seen in profile.
 Insc.: (by Webb) B: *the Cornice (?) for this ffountaine.*
 Pen and cross-hatching (407×260).

Lit. and reprd.: *King's Arcadia*, p. 157.

There were several conduit heads in the hill of Greenwich Park and presumably this was proposed for one of them. Like the designs for the Queen's House chimney-pieces this is yet another example of Queen Henrietta Maria calling upon one of her compatriots to supply designs for execution by the Office of Works (cf. John Harris, 'Inigo Jones and his French Sources', *Metropolitan Museum of Art Bulletin* (May 1961), 256–64).

MAIDEN BRADLEY (WILTS.) (Pl. 73)

92 (Gotch 1/56)
 Design for Colonel Ludlow's house.
 Plan of ground and first floors. With scale.
 Insc.: verso (by Webb) *Colonel Ludlow at Mayden Bradley, Wiltshire.*
 Pen and wash (369×452).
 Watermark.

This design can be dated within fairly narrow limits. Ludlow was made a Colonel in July 1644; he is unlikely to have commissioned such a design before his election to Parliament in May 1646, and he was made a Lieutenant-General in July 1650. The Ludlow house was called South Court (now New Mead), and if this design was executed it was demolished *c.*1881.

WILTON HOUSE (WILTS.) *see under* INIGO JONES, WILTON HOUSE

UNIDENTIFIED DESIGNS

93 (Gotch 1/54A)
 Design for a five-bay villa with lateral colonnaded wings and single-storey pavilions
 (Pl. 74).
 Elevation. With scale.
 s.: *Jo: Webb.*
 Pen and wash (394 × 520).

This might be a purely theoretical study although the drafting is quite different from
the other known theoretical drawings. The colonnades and wings are derived from
Palladio, ii. 57.

94 (Gotch 1/54)
 Design for a five-bay villa with lateral colonnades and wings with towers (Pl. 75).
 Elevation. With scale.
 Pen and wash (355 × 470).
 Watermark.

Lit. and reprd.: W. G. Keith, 'Drawings by Vincenzo Scamozzi', *RIBA Journal* (Mar.
1935), 534–5, Fig. 14.

Here we find Webb looking through his Scamozzi, with his eye also perhaps on
original drawings by Scamozzi in his or Jones's collection. The villa, almost certainly a
projected design, is a rendering of the Villa Molini (Scamozzi, iii. 275), its wings partly
from the Villa Trevisani (Scamozzi, iii. 293).

Designs (2) for a country house or palace arranged around a courtyard (Pls. 76–7).

95 (Gotch 1/49)
 Elevation of a courtyard front with sections through the flanking wings. With scale.
 Pen and wash (420 × 546).
 Watermark.

96 (Gotch 1/50)
 Elevation to a larger scale of the centre part of the courtyard front. With scale.
 Pen and wash with body colour added (310 × 387).
 Watermark.

This might be a project for a palace, although the armorial cartouche seems surmounted by a coronet. The frontage proposed measures 230 feet. There is some stylistic relation between these elevations and Webb's theoretical projects, e.g. RIBA BD V/14 or BD V/24[3].

97 (Gotch 1/51)
 Design for a large country house or palace (Pl. 78).
 Elevation (A) of a porticoed front and a section (B) through a courtyard.
 Insc.: verso (by Webb) with calculations and measurements.
 Pencil (450×350).
 Watermark.

This design has sometimes been related to Belvoir Castle, the designs for which are in the RIBA. However, it is closer to no. 125, a design by an unidentified Italian architect, perhaps for a palace in Whitehall.

Designs (2) for a large Palladian country house (Pls. 79–80).

98 (Gotch 1/61)
 Elevation of a rusticated block of nine bays and two storeys with a two-storey portico *in antis*. Attached lateral wings of seven bays with three arched openings in the centre of the ground floor. With scale.
 Pen and wash (310×400).
 Watermark.

99 (Gotch 1/61A)
 Elevation as in 98, but without rustication; the wings with the central three bays projecting slightly forward and pedimented. Pencil amendments suggesting a superimposed order to the main block.
 Pen and wash (165×700).

Both the above are related to Chatsworth 88 and 89 (a plan and elevation), the latter being no. 99 drawn out with the superimposed order. The Chatsworth plan includes a columnar atrium of Palladian derivation (e.g. Palladio, ii. 75). The serious intent of the design is underlined by the fact that the Chatsworth elevation is over 5 feet long.

100 (Gotch 1/52C)
 Design for a country house with a five-bay loggia of giant columns set between
 projecting wings (Pl. 81).
 Elevation. With scale.
 Pen and wash (370×450).

This is possibly a design for rebuilding part of an earlier house and may be related to
the following design, no. 101.

101 (Gotch 1/52B)
 Incomplete section through a courtyard of a nine-bay country house with an Ionic
 portico *in antis* raised upon an arcade of three arches (Pl. 82). With scale.
 Pen and wash (355×470).

Like the immediate preceding this may be for rebuilding an earlier house. Its extent
of front is 127 feet and the width of the courtyard 93 feet.

102 (Gotch 1/58H)
 Design for a porticoed lodge, cross shape in plan (Pl. 83).
 Plan and elevation.
 Pen, pencil, and wash (355×255).

Perhaps a design for a small hunting-lodge. At this date classical porticoed garden or
park buildings of this kind are almost unknown in England, and a design such as this
is prophetic of the eighteenth-century neo-Palladian garden temple.

103 (Gotch 11/88)
 Two studies for an overmantel incorporating an earl's coronet and two studies for a
 broken pediment of the overmantel (Pl. 84).
 Pen and pencil (350×235).

This type of overmantel can be compared to Webb's designs for chimney-pieces and
overmantels in the RIBA, e.g. at Drayton for the Earl of Mordaunt, 1653 (BD IV/3[1]);
at Gunnersbury for Sergeant Maynard, 1658 (BD IV/4); and at Northumberland House
for the Earl of Northumberland, 1660 (BD IV/7[2]).

Designs (2) for a fountain (Pls. 85–6).

104 (Gotch I/29)
Rough free-hand study derived from Maggi's *Fontane Diverse . . . di Roma* (1618), together with a modified pen rendering.
Insc.: (by Webb) *ffontane di Giovanno | Maggi Romano | Roma 1618.*
Pencil and pen (310×203).

105 (Gotch I/30)
The modified fountain presented as a finished design, the pediment part on a laid-down flap.
Pen and pencil (310×203).

106 (Gotch II/94)
Drawing for the title-page of Bishop Brian Walton's *Biblia Sacra Polyglotta* (London, 1657) (Pl. 87).
Insc.: (by Webb?) *The Assention of Baronius.*
Pen and wash (430×285).

The drawing shows a heavy monumental structure with a pair of Corinthian columns rising on either side from a deep plinth to support the entablature; above again, two pedestals with a drum-shaped block between them. In the central recess a large scroll upheld by an angel on which the lines of the title are indicated; on a tablet below, further lines indicating the imprint. Standing on the plinth: left, Moses, bearded in robe and cloak and bare-footed, holds the tablets of the Law; right, Aaron in the vestments and accoutrements described in Exodus 28: 4–29. Flanking the title-sheet and confronting each other: left, a bearded cloaked figure holding a scroll; right, another holding a saw. Along the cornice, two pairs of cherubim and in the centre a trophy of weapons lying across or fixed in a circular bracket. On top of the entablature rest the symbols of the Evangelists—the Angel with pen and ink-well, the Lion, the Bull, and the Eagle with ink-well in his beak. On the pedestals: left, St. Peter with the keys and a book; right, St. Paul with a book; just above the book three rubbed versions of the hilt of a sword. On the faces of the plinth: left, a scene representing *Adam and Eve and the Serpent*; and right, *The Ark on Mt. Ararat*; on the faces of the pedestals, left, *The Nativity*, and right, *The Ascension*; on the central drum *The Deposition*. Above the drum a triangle within a radiance of light.

The design as a whole symbolizes the Bible; the space above the plinth represents the Old Testament with Moses as the Lawgiver of Israel and Aaron as its chief priest; the scroll suggests that the figure, left, at the back is a prophet; the right-hand figure is Isaiah who holds the instrument of his death. The cherubim proclaim the holiness of

all. Above the cornice, resting on the foundations of the world of Israel, is the world of the New Testament with the Evangelists, with Peter, the scourge of the heretic, and Paul the converter of the heathen. The scenes shown likewise belong to the Old Testament below the cornice, to the New Testament above. The weapons now laid down exemplify the peace to be brought to all men by the coming of Christ. The triangle represents the Trinity, a form adopted originally by the Calvinists to whom the image of the Divinity was abhorrent. It summarizes the doctrine of the great majority of churches.

The two worlds are further connected. In his Preface (A2 *f*) Walton emphasizes that the Church as established by Christ was the heir to the Old Testament. This signifies that the characters and events of the Old Testament should prefigure those of the New Testament. Moses as Lawgiver and Aaron as the mediator between God and his people prefigure Christ; Isaiah foretold the coming of the Messiah. The scenes on the faces of the plinth and the pedestals also correspond—*The Fall of Man* and his redemption through *The Ascension of Christ*, the hope of *The Ark* fulfilled in *The Nativity*.

This drawing differs in various ways from the title-page etched by Hollar. In the title-page the triangle has been omitted; instead a wall surmounted by a mask rises from the centre of the cornice. It is divided, the bottom part showing three scenes, *The Supper at Emmaus*, *The Deposition*, and *The Resurrection*, and the upper, a representation of *The Pentecost*, the gift of tongues, which is a direct reference to the nature and purpose of the Polyglot Bible itself. Again, in the etching Paul has his sword. Moses is accompanied by a second bearded man carrying a pile of manna (?) prefiguring the Eucharist. Isaiah is behind him. Aaron holds a smoking censer and has a youth in attendance. The prophet opposite Isaiah is Elisha with the wheels of his chariot, prefiguring the Ascension. The title is inscribed on the central tablet and the angel is omitted. The trophy has been replaced by the crown of thorns.

Webb certainly studied the engraved title-pages to earlier bibles. This drawing owes much to Cornelis Boel's engraving for King James's Bible of 1611. Since it differs considerably from Hollar's etching there must have been other studies or at least one other—the definitive version (Margery Corbett).

107 (Gotch 1/33)
Design for a mausoleum (Pl. 88).
Plan, elevation, section, and, verso, part of the vaulted entrance vestibule, drawn without clear indication as to floor level.
Pen and ink, pencil, and brown and blue washes (possibly added later?) (552 × 440).
Watermark.

Lit. and reprd.: *King's Arcadia*, p. 136; A. A. Tait, 'Inigo Jones's Stone-heng', *Burl. Mag.* (1978), Pl. 32.

This drawing was first published as a scheme by Inigo Jones for a 'Royal Mausoleum for James I'. However, the drawing, especially the style of hatching and the figuration, particularly in the section, are certainly in John Webb's hand, as is the rusticated opening and cartouche of the elevation. Yet there can be little doubt that this was some sort of mausoleum, possibly a memorial one for the Royal Martyr, Charles I. It was certainly monumental. The section shows a circular main floor of 100 feet in diameter, entered by four doors which are served by staircases rising from the ground floor. It is lit by an oculus in a Pantheon-like dome. Though classically conceived, it lacks the sculpture and tree-planting associated with imperial mausoleums, especially that of Hadrian, and while its scale is that of Halicarnassus, its composition little conforms to the description given in Pliny's *Natural History*. It corresponds generally, however, with the elevation of Hadrian's mausoleum given in Labacco, *L'Architettura* (Rome, 1552), Pls. 1 and 2. Webb was undoubtedly very familiar with all forms of mausoleums in Antiquity as his editorship of Jones's *The Most Notable Antiquity of Great Britain Vulgarly called Stone-Heng* (London, 1655) makes clear (see pp. 29–30). The style of draughtsmanship, especially of the section and elevation, has no parallel with any other group of drawings in the collection, though the building's heroic scale is perhaps nearest the church plan, no. 147. It is outstanding too in the austere 'neo-classicism' of its elevation.

ISAAC DE CAUS

WALTHAM ABBEY (ESSEX) (Pl. 89)

108 (Gotch 11/96)
 Survey plan or plan for laying out part of the gardens.
 Insc.: (by de Caus) *Lord deny | wallton abby.*
 Pen and pencil (425×565).

Edward Denny was created Baron Denny in 1624 and Earl of Norwich in 1626, so if this drawing had been made after 1626 it would presumably have been inscribed for Lord Norwich. An account of the Abbey may be found in a *New and Complete History of Essex*, iv (Chelmsford, 1771), pp. 155 ff.

WILTON HOUSE (WILTS.) (Pls. 90–1)

Two prospects drawn for engraving.

109 (Gotch unnumbered)
 Elevated prospect from the south showing the garden terminated by de Caus's portico project for the south front.
 Insc.: (in another hand) *Wilton—by Callot* (*Callot* smudged out), and (in another hand) *Isaac de caus.*
 Pencil and pen (450×585).

110 (Gotch unnumbered)
 Elevated prospect of the formal garden from the north, the vista framed by trees with figures in the foreground.
 Insc.: (in another hand) *Wilton by Callot* and (in another hand) *Isaac de caus.*
 Pencil and pen (432×559).
 Engr.: Isaac de Caus, *Le Jardin de Vuillton* (or *Wilton Garden*) (*c.*1654), Pls. 3–4.

Lit. and reprd.: H. M. Colvin, 'The South Front of Wilton House', *Archaeological Journal*, cxi (1954), pp. 181–90, Pl. XXVII; *King's Arcadia*, p. 191.

For a house so important in English country-house typology, the building history of Wilton still needs some elucidation. To summarize, Philip, fourth Earl of Pembroke, inherited in 1630, and according to Aubrey 'about 1633' Inigo Jones, then too busy at Greenwich, recommended Isaac de Caus to perform Lord Pembroke's building works. This ties in with accounts for constructions in the gardens in 1632–3, and with instructions given to de Caus on 14 March 1636 to demolish the old south front and rebuild it

'according to ye Plott which is agreed'. It is assumed that this 'Plott' corresponded to perspective no. 109. That it was not engraved, unlike its companion perspective, and therefore not included in de Caus's *Wilton Garden*, is suggestive that this grand portico design was abandoned at an early stage, although the parterre garden had already been aligned upon the whole width of the intended front. Nicholas Stone was paid for work 'by Mr Decans appointment' in 1637 and 1639. Vertue, who was a friend of the tenth Earl, specified the date of completion as 1640. The look of the front before the fire in 1649 is unrecorded, unless it was built to de Caus's reduced, hipped-roofed elevation in the RIBA. A mid-seventeenth-century view in the Society of Antiquaries does, in fact, show a hipped roof with dormers between the two towers and behind the balustrade.

WILTON HOUSE (Pl. 92)

III (Gotch I/58G)
 Elevation for the flank of a chapel projecting from the west side of the quadrangle and showing one bay (with approach stairs) of an unexecuted south front project. Pen and wash (260×395).

The plan of the Wilton Chapel is shown on the plan of Wilton published by Campbell in the second volume of *Vitruvius Britannicus* (1717). It does, indeed, project from the west side of the quadrangle, but it neither projects as far as in this drawing, nor does it have any windows in the south elevation. A comparison with Jones's St. James's Chapel need hardly be made.

WILTON HOUSE (Pl. 93)

112 (Gotch II/78)
 Two sections through the elevated terrace and lower garden of the south parterre. Pencil and wash (235×355).

This section, showing a fountain and a pair of ogee-cupolaed pavilions with twisted columns, can be identified in de Caus's *Wilton Garden*, which engravings display other examples of the use of this order. The design must have been drawn in the early 1630s, which is the period of twisted orders on the Gorges tomb in Salisbury Cathedral and on the porch of St. Mary's, Oxford. The source of such twisted columns is probably the classical 'Salomonic' column in St. Peter's, engraved by Antonio Lafreri in his contemporary *Speculum Romananae*.

WILTON HOUSE (Pls. 94–7)

Designs (4) for the grotto.

113 (Gotch 1/32C)
 Partly completed elevation of an inner wall with Europa in one panel and Galathea
 proposed for the other. With scale.
 Insc.: (in another hand) *Europe* and *galethia*.
 Pencil (210×325).

114 (Gotch 1/32E)
 Study for two panels with Amphitrite and Neptune.
 Pen and pencil (184×298).
 Watermark.

115 (Gotch 1/32F)
 Study for two panels with Amphitrite and Neptune.
 Pen, pencil, and wash (184×298).

116 (Gotch 1/32D)
 Study for three panels with Neptune and Mermen.
 Pencil (204×330).
 Watermark.

These designs are for the grotto sited on the south edge of the Great Parterre. A plan
and two sections were engraved in de Caus's *Wilton Garden*, one section corresponding
to no. 113. The grotto belongs to the garden works initiated in 1632. De Caus's en-
gravings are undated, but one of a gladiator is inscribed *A Colecktione OF fountaines
Gardens And Statues, P Stentt 1654*. The style of such garden works is based upon
Salomon de Caus's *Raison Des Forces Mouvantes* of 1615, with engravings of his designs
for grottoes at Richmond Palace for Henry Prince of Wales *c.*1612, and for the Prince
and Princess Palatine at Heidelberg.

117 (Gotch 1/58F)
 Design for a five-bay building of institutional or public use (Pl. 98).
 Elevation.
 Pen, pencil, and wash (260×400).

The style of this compares with de Caus's Wilton elevation in the RIBA.

118 (Gotch 1/58B)
 Design for a seven-bay house, an elevation composed in three parts; three inner bays topped with a large segmental pediment, and lower, flanking, recessed bays capped by triangular pediments. The ground-floor entrance with a six-column porch and above this a Palladian window (Pl. 99). With scale.
 Pen with pencil modifications (355×240).
 Watermark.
 Dubiously ascribed to de Caus.

119 (Gotch 1/51A)
 Elevation for a French-style country house with a nobleman's armorials in the pediment (Pl. 100).
 Pencil and wash (394×502).

This tentatively could be a design for Wilton, but it could equally be for Stalbridge Park, Dorset, for Richard Boyle, first Earl of Cork, or the fourth Earl of Bedford at Woburn Abbey c.1630. In December 1638 Lord Cork records, 'I gave mounsier decon, the french architect who belongs to my L. chamberleyn (Lord Pembroke) Vli and to owld Hopkins Xis for drawing me a platt, for contriving my new intended bwylding over the great sellar at Stalbridge.'[1] As far as topographical documents show, the sixteenth-century house at Stalbridge was never rebuilt.

120 (Gotch 1/53A)
 Elevation for a small five-bay, two-storey house with a hipped roof in the 'Maltravers' style (Pl. 101).
 Pen and wash (470×356).

This design is clearly based upon Jones's 1638 design for Lord Maltravers. De Caus could have known it either through his association with Jones (e.g. at Covent Garden where similar small houses flanked the church), or may have known the house if it was built. A similar front was built for the Earl of Arundel at Arundel House, as shown in W. Hollar's engraving of the courtyard there in 1646.

[1] *Lismore Papers*, ed. A. B. Grosart, 1st Ser. v (1886), p. 64.

121 (Gotch 1/32B)
> Designs for two fountains, one (A) with reversed dolphins supporting two tiers of
> basins, the other (B) with dragons surrounding a pedestal supporting a statue, perhaps
> of Amphitrite (Pl. 102).
> Pencil and wash (285×440).
> Watermark.

For a similar Amphitrite-type fountain, cf. Fanelli's at Hampton Court that originated
from de Caus's garden at Somerset House.

122 (Gotch 1/32)
> Design for a two-storey fountain with superimposed open arches and ample frosted
> rustication (Pl. 103).
> Pen and pencil (394×260).

For a fountain of this mannerist type, cf. Bockler's *Architectura Curiosa Nova* (1664).
The ascription to de Caus is uncertain, for the hatching is in John Webb's manner.

ITALY: QUINTO: VILLA THIENE *see* APPENDIX

123 (Gotch 1/32A)
> (H. Bedy)
> Elevation of a wall fountain.
> Design for a wall fountain with, verso, a rough study for the front of a two-storey,
> three-bay house with a pergola to the middle window above the door, and some
> indication of an attached wing to the right-hand side (Pl. 104).
> Insc.: *Tennty pounds is demaunded | for one Phelp but referred | tue me if it be worth it |*
> *(F Fea (?))*.
> Pen and pencil (185×280).
> Watermark.

This could be for a garden or wall fountain, but it could equally well be for a fountain
in a hall or basement of a house. The signature, difficult to decipher, has also been read
as F. Pedy.

124 (Gotch unnumbered)
 An incomplete survey of, or a design for, a large country house or palace (Pl. 105).
 Plan.
 Pencil and pen (445×571).

This is a plan of a very large, perhaps sixteenth-century, building, covering an area of at
least 310 by 280 feet. Although this looks partly a survey, there appear to be revisions
to the order of pilasters at the angles of the colonnaded courtyard.

125 (Gotch 1/48)
 Design for a great country house or palace (Pl. 106).
 Elevation of a porticoed courtyard front with sections through the wings.
 Insc.: with lettering and *Nuᵒ 6ᵒ*, and verso (by Webb) with many calculations and
 numerations referring to designs for Whitehall, e.g. *ye Banquetting House & ye rest of ye*
 Lodgings.
 Pen and wash (483×762).
 Watermark.

This design is incorporated in this part of the catalogue because it seems to be directly
related to Webb and his designs and drawings of Whitehall Palace. The hand of the
drawing is decidedly Italianate of the early seventeenth century. However, the lettering
Nuᵒ 6ᵒ is similar to that on the Augsburg drawings after Elias Holl (cf APPENDIX,
nos. 131–3), but these drawings are in a different hand. The temptation is to ascribe the
design to an architect proffering a project for a new Stuart palace, such as the mysterious
Medicean architect Constantino de Servi might have made for rebuilding Richmond
Palace, whose gardens he was altering for Henry Prince of Wales *c.*1611. Even in Italy
giant porticoes of this type are a rarity for country houses or palaces. The obvious
parallel is to Jones's Star Chamber designs of 1617. Significantly, these are also patently
derivative from some lost source, perhaps the Scamozzi designs once in Lord Arundel's
collection. As far as Webb is concerned the design is a starting-point for his Durham
House designs of *c.*1649 and perhaps also those for Belvoir Castle.

126 (Gotch 11/13(13))
 Design for a palace at Whitehall (Pl. 107).
 Elevation of two and a half bays of the upper part of a front.
 Pencil and pen (845×580).

This painterly drawing remains unattributed. It was not known to Dr Whinney when she published Z1, Chatsworth 67 ('John Webb's Drawings for Whitehall Palace', *Walpole Soc.* 31 (1946), Pl. XXIIb), a section through a large palace incorporating the existing Banqueting House. This Worcester design can be related to the courtyard elevation of this Chatsworth drawing as possibly an alternative, or part of the elevation on another front. Although the hand is an elegant one, the design is undisciplined, suggestive of a Dutch-influenced City of London mason, rather than a sophisticate such as Hugh May.

APPENDIX

CONTINENTAL DESIGNS AND DRAWINGS

IT is natural that the Worcester College Collection should contain a few miscellaneous drawings other than those by Jones, Webb, and de Caus, for as with the drawings in Drawer 8 of the Burlington–Devonshire Collection at the RIBA and those scattered in various 'Burlington' volumes at Chatsworth, the corpus of Palladio's designs must have contained many miscellaneous drawings by other architects and draughtsmen. Many of these must have attracted William and John Talman when they possessed the Palladio and Jones Collections, and could have become detached from the main corpus. It is significant that many collections of drawings of Talman provenance contain evidence that points to at least a Jones provenance (e.g. Cotelle albums in the Ashmolean Museum). The following are listed for completeness only.

127 (Gotch 1/47H): Palladio, design for the façade of San Petronio, Bologna.

128 (Gotch 1/58A): Palladio, design for the Villa Thiene at Quinto, with amendments in the hand of John Webb.

129 (Gotch 1/58E): Palladio, design for the Palazzo Chiericati, Vicenza.

130 (Gotch 11/83): unidentified sixteenth-century draughtsman, copy(?) of antique Roman wall decoration from a building of the Emperor Augustus.

131 (Gotch 11/85): perspective of Elias Holl's Town Hall, Augsburg.

132 (Gotch 11/86): section through Augsburg Town Hall.

133 (Gotch 11/87): perspective of Holl's Perlach Tower. The hand of nos. 131–3 has not been identified. Number 132 is inscribed *Profylo Nu° 6°* (or *b°*), the latter part of which inscription is identical to that on HT 69 under Anonymous Designs (Pl. 106) included in the main body of the catalogue because its verso is profusely annotated by Webb and the design had profound influence upon Webb's own style. If one reasonably assumes these Augsburg drawings to have found their way into the Jones/Webb office by the late 1640s, if not the late 1630s, then these are the earliest records of Holl's works, if they are, indeed, topographical. They may be used as further evidence that Jones visited Augsburg in 1613 or had some connection with Holl and Heins, the two principal architects in Augsburg in the early seventeenth century.

134 (Gotch 11/89): copy (by Webb ?) of an 'antique' architectural detail from the tapestry of Raphael's Elymas, the prophet struck with blindness by St. Paul.

135 (Gotch 11/90): Italian late sixteenth-century design for, or drawing of, the sounding-board and canopy of a pulpit.

136 (Gotch 11/91): Italian late sixteenth-century design for, or drawing of, a base or stand.

137 (Gotch 11/95 recto and verso) Gotch: plan of a square Palladian house or villa and plan of a square collonade, both projected as cubes as if intended for a work on perspective. Possibly by John Webb.

138 (Gotch 11/98): Italian late sixteenth-century design for, or drawing of, one bay of a screen to a choir or chapel, probably the same hand as no. 135.

139 (Gotch 11/99): design for a monument to a nobleman, probably Venetian mid to late sixteenth century and perhaps from Palladio's circle.

THE
THEORETICAL DRAWINGS
OF JOHN WEBB

A. A. TAIT

THE seventeenth-century drawings which form this part of the Worcester Collection show the refinement of John Webb's style during his enforced retirement from the Office of Works throughout the Interregnum. Through the effective ending of Jones's career at the beginning of the Civil War and his death in 1652, Webb had both time and freedom to develop unhindered his own architectural ideas. By and large, such a process is outlined in the catalogue and summarized in the following few paragraphs. These drawings represent Webb at work over several years in the late 1640s, studying and copying the classical masters of architecture, reinterpreting Jones's schemes and, in both senses, preparing his own future plans. While such drawings are only theoretical in the broadest sense, it is a label which covers a diversity of intellectual purpose.

The drawings may be arranged according to subject, style, and to some extent, watermark. Unfortunately, the evidence of such marks can only be interpreted very generally for a large number of the sheets were pasted on to their mounts when the drawings were arranged in two folios early in this century. Thus, many of them appear to have neither watermark nor countermark. However, where these marks can be discerned, they largely agree with an arrangement of the drawings according to subject. The sheets of small-scale plans and elevations, 172–93 (Pls. 115–21), and the two drawings based on Palladio's schemes for the Basilica at Vicenza, 170–1 (Pl. 114), all share the same watermark of jug and surmount. The free-hand ink drawings of churches, 146–53 (Pls. 110–11), are watermarked with a grapes and foolscap device. The third mark that is commonly found is a countermark rather than watermark, and this appears on a series of watered-ink and wash drawings for temples, 194–7 (Pl. 122), and two related sheets, 159 and 160. All such marks were familiar in the seventeenth century, but none seem to be especially characteristic of English paper-mills at this time.

Though together these drawings form several complementary groups, they by no means look alike. The style and technique of the draughtsman varied, and it is likely that they were executed over a period of several years. Webb's dated drawings of this period—for Wilton of 1648 and Lamport of c.1654—are markedly different in their presentation from those executed before the Civil War. Instead of the rather heavy ink drawing with strong cross-hatched shadowing, there is a lighter more graceful style with an ink or grey wash taking the place of the hatching. It might therefore be presumed that the series of pencil and wash drawings for churches and temples, 194–207 (Pl. 122), come after the possibly more youthful style of the ink drawings of the various classical orders, 208–26 and 240–8 (Pl. 124), and the series of small plans and elevations. Unfortunately, Webb's development as a draughtsman was neither so straightforward nor so logical. On sheet 160 (Pl. 112), where the two contrasting styles of draughtsmanship are shown, it is the hatched drawing in his early manner that has been added to

overlay in part the careful pencil drawings. So it would suggest that there was at this time no clearly defined pattern in Webb's draughtsmanship which might just as readily vary from the meticulously neat drawing of 162 (Pl. 113) to the more attractive and impressionistic manner of his designs for a circular church (Pls. 110–11). But more often this seemingly dramatic contrast is one of media rather than style or chronology. Indeed, it is likely that the bulk of the drawings were executed by Webb during the 1640s when, to a Royalist at least, Inigo Jones was still Mr Surveyor, as sheet 191 proves. Significantly, it was in January of 1643 that Webb dated the notes he had written beside a villa plan in his copy of Serlio's *Architettura*.[1] This drawing, for a small villa with an oval hall, reappears in diagrammatic form in 181 Y (Pl. 117).

As has been said, there is a considerable stylistic range in these drawings. The group of designs for churches and temples, 161–7 and 194–207 (Pl. 122), are drawn largely in watered ink and differ not only in technique but in draughtsmanship from the rest of the collection. In this instance, the hand is neater and more accurate, and might in many ways be taken for the work of a pupil or the youthful Webb. Yet two of these sheets bear Webb's mature handwriting, 165 and 202, and several of them are not unlike the style of a Webb drawing after Palladio, 169. Outstandingly different from these and the orthodox Webb drawings in the collection are sheets 147–50 (Pls. 110–11). Boldly executed in ink and wash, without hatching, they seem more sophisticated than the other wash drawings and nearer the style as ultimately found in Webb's drawings for Greenwich in the 1660s. They seem likely to be his handiwork. The verso of sheet 148 has numerous notes by him on the recto design and the drawing of the section through the dome, 150 (Pl. 111), is close to the conventional Webb drawing of such a subject, as sheet 155 suggests.

Most of the drawings are copies of varying accuracy. They are taken from a range of architectural authors whose works had all been published before 1630. As this collection makes clear, Webb copied designs which appeared in Serlio's *Tutte L'Opere d'Architettura et Prospetiua* (1619), in Palladio's *I Quattro Libri* (1601), in *Le Premier Tome de l'Architecture de Philibert de l'Orme* (1567), in Viola Zanini's *Della Architettura* (1629), in Rubens's *Palazzi di Genova* (1622), and especially in Scamozzi's *L'Idea della Architettura Universale* (1615). He also seems to have used the 1567 Bartoli edition of Alberti and the Rusconi *Della Architettura* of 1590.[2] Apart from Serlio, for whom he showed a decided affection, all these books had been owned by Inigo Jones and were inherited by Webb on his death in 1652. Besides making copies after the illustrations of these authors

[1] John Webb's copy of Serlio, *Tutte L'Opere d'Architettura et Prospetiua* (Venice, 1619), is in the RIBA. Webb's notes were dated 16 January 1643, and annotated the text and woodcut for 'Della Prima Casa fuori della Citta' (ibid., Libro Settimo, p. 2).

[2] Though Webb inherited the bulk of Jones's books, there is no catalogue of his library. However, the Bartoli edition of Alberti was the one owned by Jones, and inherited by Webb, and was a popular one in seventeenth-century England. Rusconi, *Della Architettura* (Venice, 1590) was considerably rarer and was not owned by Jones, see Catalogue, *King's Arcadia*, pp. 63–7, 217–18.

and summarizing their texts in his essays on windows and the Ionic order, Webb also appears to have made extensive use of Jones's collection of architectural drawings which presumably he had also inherited. The Montano drawings of classical capitals, now in the Ashmolean Museum and probably originally owned by him, were referred to by Webb in his *A Vindication of Stone-Heng, Restored* (1665), and at least one of these directly inspired his doorway capital for the King's Cabinet at Greenwich, also of 1665.[1] But in all of this, Palladio's drawings were the most important, and Webb frequently turned to them in preference to the woodcuts of *I Quattro Libri*. It is possible, too, that in making his copies after Scamozzi (see 208–19 and 240–8) he may have had access to the collection of Scamozzi drawings which, until 1654, belonged to the Earl of Arundel.[2]

Webb had probably several uses in mind for such a corpus of drawings. The sheets of small-scale plans, elevations, and various details, 188–92 (Pls. 119–21)—without doubt the residue of a much larger collection—were intended as some sort of thesaurus, possibly for the Office of Works. They were deliberately drawn on scored paper which allowed their easy enlargement, practically to any scale, by the use of the sector or joint rule. Together they would have provided a quick guide to the old masters of architecture as well as giving a constant source of inspiration, and in that way paralleled similar drawings made by Giorgio Vasari il Giovane for his *La Città Ideale* (1598), and by Palladio himself.[3]

The various church designs had probably a similar purpose. Indeed it is possible to follow in them the evolution of Jones's small churches of the 1630s, like St. Paul's Covent Garden or Hale Church in Hampshire. 188A probably showed its immediate origins in Serlio and its more refined form in the elevation for the cruciform church

[1] Webb wrote in his *Vindication of Stone-Heng, Restored* that, 'Johannes Baptista Montanus in his collection of the Temples of the Ancients, gives us many Precedents of those that were mixt and composed of these several Forms' (p. 110). Webb was probably referring to Montano, *Scielta d varii tempietti antichi* (Rome, 1624). He and Jones, however, owned a collection of drawings of antique capitals by Montano and others which are now in the Talman Collection in the Ashmolean; see John Harris, *Catalogue of the Drawings Collection of the Royal Institute of British Architects. Inigo Jones and John Webb* (Farnborough, 1973), p. 27. There are copies of these by Webb in the RIBA, and his drawing of a capital with a pegasus provides a close parallel with the Unicorn capital of the Greenwich design (ibid., p. 25, fig. 150).

[2] According to Lionel Cust, 'Notes on the Collection formed by Thomas Howard, Earl of Arundel and Surrey', *Burl. Mag.* xix (1911), p. 282, these drawings appeared among Arundel's property in Amsterdam in 1654. They were listed as '12 and 2 forcieri: casse con disegne tra gli quali sona 2 forcieri con desegni d'Architettura de Vincenzo Scamozzi'. There are no traces of such a collection of Scamozzi drawings surviving in late seventeenth- or eighteenth-century England, though there are Scamozzi drawings scattered among the Burlington–Devonshire Collections at Chatsworth and the RIBA. It is possible that Webb's drawings after the classical orders, some of which differ from the plates given in Scamozzi's *L'Idea della Architettura Universale*, were taken from the missing drawings (see 210–26).

[3] For the Vasari drawings, see Franco Borsi, *La Città Ideale* (Rome, 1970), Pls. 1–50. There are of course similar sheets of plans by Palladio, see Giangiorgio Zorzi, *Le Opere pubbliche e i palazzi privati di Andrea Palladio* (Venice, 1965), p. 37, Pls. 31, 32. Four drawings of this sort by John Webb are in the RIBA (Harris, *Catalogue . . . Inigo Jones and John Webb*, p. 27, Pl. 208).

146 (Pl. 109). However, the drawings after the classical order and the sheets illustrating several temple forms according to Vitruvius, 194–207, had undoubtedly a more academic role. It is probable that the drawings of the details of the various orders, 210–26, were inspired by a series of Palladian designs associated with *1 Quattro Libri*, and now in the Burlington–Devonshire collection.[1] Several of them carry Webb's annotations and are similar in character to this group of Worcester drawings. It is highly likely that Webb intended to publish some treatise on architecture and these are the surviving illustrations to his manuscript. The notes he made in his interleaved copy of Palladio—Venice, 1601, the same edition as Jones's—show him preparing the ground for such a work. So much so that a highly finished drawing such as that for the Ionic order, 210 (Pl. 123), was probably intended to serve as the printer's block. Webb's rambling and repetitive manuscripts, 'of wyndowes', 231–3 (Pl. 125), and 'of the Ionick Order', 227–30, were presumably the rough draft for the written part of such a treatise. From the form of the manuscripts, it is possible that he may have been inspired by Freart's *Parallele de l'Architecture Antique et de la Moderne*, which had appeared in 1650. To ascribe the manuscripts to a date around 1650 seems reasonable, for Webb was certainly interested at this time in gaining some sort of literary reputation. In 1655 he edited, or rather rewrote and published, Jones's notes on the reconstruction of Stonehenge and, like them, these manuscripts may well be part of the same critical exploration of the roots of classical architecture. For Webb ingenuously wrote of Stonehenge that 'the Rarity of its Invention, being different in Form from all I have seen before; likewise, of as beautiful *Proportions*, as elegant in *Order* and as stately in *Aspect*, as any'.[2]

Thus this part of the collection documents Webb's career after his departure from the Office of Works in 1643. It points to the practical importance of Palladio's drawings for both Jones and Webb, and makes plain what sizable part of the present Burlington–Devonshire collection was in their hands. It shows Webb revising and extending his classical repertoire on a most ambitious scale and preparing for his anticipated, but sadly never realized, début as Jones's successor—as the new Mr Surveyor.

[1] For these drawings see Heinz Spielman, *Andrea Palladio und die Antike* (1966), p. 140–2.

[2] Inigo Jones, *The Most Notable Antiquity of Great Britain . . . called Stone-Heng* (London, 1655), p. 1.

140 (Gotch 1/28) (Pl. 108)
 Three-bay elevation and circular plan for a grotto.
 Insc.: *Grottas.*
 Pen and ink (85×230).
 Watermark.

Plan A is annotated 'Serly lib: 3: fo: 69: a' and is identified by Serlio as an 'edifico e fuori di Roma appresso San Sebastiano'. Webb gives notes describing how this might be turned into a grotto: 'This Invention may serve for a grotta with some Arches or Loggia before it & / being vaulted a bove ye solidenesse (may) is / made to fastayne ye . . . best & it is advanced with neeches / answerable to those on ye sydes of ye wall within ye floore / may bee voyd & a stayre made to ascend upp into a Terras / over ye grotta:' The elevation, B, is also taken from Serlio, 'Lib: 4: fo: 137', and Webb has changed its function by adding sculpture to the niches and suggesting a use for it: 'many tymes there may bee a / place in a building without any / opening as in a Court or in a / garden or ye like wch for adorning / whereof such an Invention as / this may bee made use off in / wch may be placed statues & other / Antiquities as ye occasion serve'. It may be compared with the fountain designs 104 and 105 (Pls. 85, 86).

141 (Gotch 1/34)
 Elevation and plan of a Corinthian Hall. With scale.
 Pen and ink with pencil (360×510).
 Countermark.

This is a copy of Palladio's Corinthian Hall (Palladio, ii. 39). The elevation is shown without the sculpture in the niches and with a plain cornice. Webb noted in his own interleaved Palladio several ideas for its adaptation, particularly 'where this hall is made to stand by it selfe as the Banquetting house at Whitehall, or where the worke is very great, then it may bee made vaulted' (Palladio, ii. 38-9).

142 (Gotch 1/35)
 Elevation and plan of a Corinthian Hall.
 Pen and ink (360×510).
 Countermark.

This is after the 'second manner' of Palladio's Corinthian Hall (Palladio, ii. 40). Like 141, it lacks sculpture and has a plain cornice. It may also be associated with a drawing in the RIBA BD XIII/20 verso. The plan of columns at the foot of B is based on the dimensions of the semi-engaged columns in B.

143A–B (Gotch 1/36)
 Ceiling plan and interior for a hall with four columns. With scale.
 Pen and ink with pencil (360×510).
 Countermark.

This is a redrawing of Palladio's Sala di Quattro Colonne (Palladio, ii. 37). Like 142, drawing A lacks sculpture in the niches and similarly differs from the drawing in the Burlington–Devonshire Collection for a Salotto Tetrastili. Webb's interleaved copy of Palladio at Worcester carries several notes on the proportioning of this room and the orders (see Palladio, ii. 36–7 and 37).

144 (Gotch 1/37)
 Latitudinal section and plan of an Egyptian Hall.
 Pen and ink (360×510).
 Countermark.

Reprd.: Per Palme, *Triumph of Peace* (Stockholm, 1956), Pl. 20; Rudolf Wittkower, 'Burlington and his Work at York', *Studies in Architectural History*, ed. W. A. Singleton (London and York, 1954), p. 58.

Both drawings are derived from Palladio's Sala Egittia (Palladio, ii. 42): on Webb's copy of the book there is a pencil note on height (ibid.). The plan given by Webb is an enlargement of that shown by Palladio and, as Wittkower pointed out, derived from the Vitruvian double cube in the over-all dimensions. The elevation A is closer to the woodcut than the drawing in the RIBA BD XIII/20, which was probably owned by Jones. According to Palme, the dimensions given here were influenced by Jones's own Banqueting House (see Palme, *Triumph of Peace*, p. 195).

145 (Gotch 1/38)
 Plan, elevation, and section of a centralized church with portico. With scale.
 Pen and ink with pencil (355×455).
 Watermark.

Reprd.: Margaret Whinney, 'Some Church Designs by John Webb', *Warburg and Courtauld Journal*, vi (1942), Pl. 40b; Eduard Sekler, *Wren and his place in European Architecture* (London, 1956), Pl. 37c.

This sheet and 146 and 151 are alike in subject and in draughtsmanship. All three are exercises by Webb in the design of a small centralized church. There are pencil alterations on the pilaster sequence at the dome crossing.

146A–D (Gotch 1/38A) (Pl. 109)
 Plan, two elevations, and section of a small centralized church. With scale.
 Pen and ink with pencil (355×455).
 Watermark.

This is a similar essay to that given in 145. The composition of the elevations is remarkably like Jones's work at St. Paul's Covent Garden, of 1631, and that of C is a larger version of 188A. It is similar, too, to the small church at Hale of 1631–2. The pencil drawings for additional sculpture are in Webb's hand.

147 (Gotch 1/39)
 Plan of a circular church with dome and portico. With scale.
 Pen and grey wash (350×455).
 Watermark.

This plan, like its elevation and section, 149 and 150, is based upon sixteenth-century schemes for St. Peter's and S. Giovanni dei Fiorentini. It may have been inspired by an anonymous study possibly for St. Peter's in the RIBA BD XV/5. As 181 shows, Webb probably had access to drawings or copies of drawings by Antonio da Sangallo the Younger. According to notes in Webb's hand on the verso, 'ye wholeground platt is comparted by equal squares each square consisting of 12 fo'. The portico plan has been added on top of a first scheme where the end bays were column and pilaster rather than coupled pilasters (*see* 149).

148 verso (Gotch 1/39)
 Notes on the design of a circular church with dome and portico.
 Pen and ink with pencil (350×455).
 Watermark.

These notes are in Webb's hand and refer to the plan given on the recto elevation on 149, and the section on 150, for a centralized church. They are divided into 'Measures without' and 'Measures within'.

149 (Gotch 1/40) (Pl. 110)
Elevation of a circular church with dome. With scale.
Pen and wash with pencil (350×455).
Watermark.

Reprd.: Margaret Whinney, *Wren* (London, 1971), Pl. 82.

This is the elevation of the plan given in sheet 147, it offers several parallels with Wren's Great Model for St. Paul's (Whinney, *Wren*, p. 90). The design of the drum has been amended and the revised drawing pasted on top.

150 (Gotch 1/41) (Pl. 111)
Section through a circular church with dome. With scale.
Pen and wash (350×455).
Watermark.

This is a section of the scheme given in 147 and 149.

151A–E (Gotch 1/42)
Plan, two elevations, and two sections of a church with portico. With scale.
Insc.: (pencil) *Inigo Jones*.
Pen and ink (355×455).
Watermark.

Reprd.: Margaret Whinney, 'Some Church Designs by John Webb', *Warburg and Courtauld Journal*, vi (1942), Pl. 40a; Reginald Blomfield, *A Short History of Renaissance Architecture in England* (2 vols., London, 1897), i. p. 112.

The signature, Inigo Jones, is an attribution of this century. This sheet, like similar drawings 145 and 146, is in Webb's hand. The plan is reminiscent of Webb's scheme for the chapel at Greenwich. The dimensions given there are similar to those on his drawing of 1664 for 'The Old Chappell' (see Harris, *Catalogue . . . Inigo Jones and John Webb*, p. 24, Fig. 120). Drawings B and E have flaps giving variant solutions.

152 (Gotch 1/43)
Lower and upper half plans of a longitudinal church with portico. With scale.
Pen and ink (360×450).

Reprd.: Margaret Whinney, 'Some Church Designs by John Webb', *Warburg and Courtauld Journal*, vi (1942), Pl. 37a; Reginald Blomfield, *Architectural Drawing and Draughtsmen* (London, 1912), p. 76.

Webb shows here a church with a nave of ten bays. The side aisle of the nave and transepts, the ambulatory and the portico, are shown as only one storey high. A flap gives an alternative scheme for the external pilasters of the choir. 153A illustrates a part elevation for the design.

153A–C (Gotch 1/44)
 Studies for a church: section and two sectional elevations. With scale.
 Pen and ink with pencil (360×450).
 Watermark.

Reprd.: Margaret Whinney, 'Some Church Designs by John Webb', *Warburg and Courtauld Journal*, vi (1942), Pl. 38A.

There are flaps added to A and C: A shows the elimination of windows to the aisle and C very substantial alterations to the façade and the addition of a campanile. The sectional elevation, A, is taken from the plan given on 152.

154A–B (Gotch 1/45)
 Two sectional elevations for a domed church, one a sketch (B). With scale.
 Pen and ink with pencil (305×405).
 Watermark.

Reprd.: Margaret Whinney, 'Some Church Designs by John Webb', *Warburg and Courtauld Journal*, vi (1942), Pl. 38B.

The pencil section, B, is a version of the drawing C on sheet 153. The sectional elevation, A, on this sheet is also a variation of 153A: the heights of the nave and gallery, given as '40: fo' and '35: fo', correspond. Both may well be connected with the design shown on 155.

155A–B (Gotch 1/46)
 Part plan and sectional elevation of a church with dome and campanile. With scale.
 Pen, pencil, and brown wash (440×360).
 Watermark.

Reprd.: Margaret Whinney, 'Some Church Designs of John Webb', *Warburg and Courtauld Journal*, vi (1942), Pl. 39B; John Summerson, 'Inigo Jones', *Proceedings of the British Academy*, l. (1964), Pl. xxviib; Eduard Sekler, *Wren and his Place in European Architecture* (London, 1956), Pl. 11B.

There is what seems to be a rough version of the elevation on sheet 154. The dimensions given in both pencil and ink on this sheet are in Webb's hand and the draughtsmanship very close to that of 150. The design itself has, clearly, very strong Laudian connections. Above the transeptal side chapel appears the 'I H S' symbol, and on the half pediment of the façade there seems to be the rayed sun, both of which appear on the pediment of Jones's scheme for St. Paul's in the RIBA BD I/2 (1). There is a small pencil sketch of the vaulting of the transept.

156 (Gotch 1/46A)
Plan of a circular church with portico.
Pen and pencil on scored paper (350×230).

Like 147, this plan may well be based on a similar scheme of Antonio da Sangallo the Younger, for San Giovanni dei Fiorentini (see Gustavo Giovannoni, *Antonio da Sangallo il Giovane*, 2 vols. (Rome, 1959), ii, fig. 170). It also shows its classical precedents in the Tempio Le Galluce (Temple of Minerva Medica: Palladio, iv. 40), a building interesting to both Jones and Webb.

157A–D verso (Gotch 1/46A verso)
Sketches for a church: façade, dome, portion of plan of façade, and detail of arcade.
Pen and pencil (350×230).

The dome shown is similar though larger than that given in 158. The incomplete elevation is possibly a rough sketch of that found in 155.

158A–C (Gotch 1/46B)
Plan and two elevations of a small church with portico.
Pen and ink with pencil alterations (305×205).

The dome of elevation B is similar to that shown in 157. The plan C may be derived from the Amphiprostyle temple shown in the Como edition of Vitruvius, ii. 53. The pencil alterations to B show the addition of lateral apses.

159 (Gotch 1/47)
　　Plan of a longitudinal church with portico and twin campaniles. With scale.
　　Pen and ink (285×220).
　　Countermark.

Both this drawing and the notes on the buildings dimensions are in Webb's hand. The seven-bay portico was to be approximately 80 feet wide with Doric columns. There is a more precise version of this plan on sheet 161. The drawing of the east end shows pencil alterations.

160 verso (Gotch 1/47 verso) (Pl. 112)
　　Elevation of a domed church and part elevation and section of a temple. With scale.
　　Pencil, pen, and ink (285×225).
　　Countermark.

The drawing, as the overlaps show, has been added to two incomplete drawings for a hypaethral dipteral temple (see 199). The sketch and dimensions are in Webb's hand.

161A–B (Gotch 1/47A)
　　Plan and west elevation of a longitudinal church with portico and twin campaniles.
　　With scale.
　　Pen and ink with pencil (370×510).

Reprd.: Eduard Sekler, *Wren and his Place in European Architecture* (London, 1956), Pl. 11C; Margaret Whinney, *Wren* (London, 1971), Pl. 63.

The plan, A, is a more accurate rendering of that given on 159, though the nave is here shortened to four bays and the portico, B, is Corinthian rather than Doric, as noted on 159—'The Pillars dorick'. The style of draughtsmanship of this and sheets 162, 163, and 164 may be associated with those of 194–207.

162A–D (Gotch 1/47B) (Pl. 113)
　　Two elevations and two sections of a longitudinal church with twin campaniles.
　　Pen and ink with pencil (355×510).

These are the elevations and sections to the design given on 161. On D there is a suggested treatment (in pencil) of the roof as a series of vaulted and compartmented bays.

163A–B (Gotch 1/47C)
 Elevation and plan of a longitudinal church with twin campaniles and circular domed chancel. With scale.
 Pen and ink (360×510).

Reprd.: Eduard Sekler, *Wren and his Place in European Architecture* (London, 1956), Pl. 11D.

This is a variation upon the design given in 161: the plan is simpler with coupled columns in the nave and a much modified east end but the elevation remains a portico flanked by twin campaniles. However, the most dramatic addition is the inclusion of a circular chancel at the east end, foreshadowing a similar addition by Wren to the Queen's Chapel, St. James's, in 1667 (see *The History of the King's Works*, v (1976), p. 247). Added flaps on B show an expansion of the top domes of the campaniles.

164A–D (Gotch 1/47D)
 Two elevations and two sections of a longitudinal church with twin campaniles and a circular domed chancel.
 Pen and ink (360×510).

These are the elevations and sections to the plan given in 163.

165A–B (Gotch 1/47E)
 Plan and elevation of a small church with portico and detached campaniles flanking the west end. With scale.
 Pen and grey wash (360×510).

Though in a different technique, this drawing is similar in subject and probably in the same hand as that of 161–4. The drawing style is close to that found in sheets 194–207. The dimension '7 fo' beside the portico of A is in Webb's hand.

166A–D (Gotch 1/47F)
 Side elevation and three sections of an apsidal church with two detached campaniles.
 Pen and grey wash (360×510).
 Countermark

These are further drawings of the church shown on 165.

167A–E (Gotch 1/47G)
 Plan, section, and three elevations of a centralized church with portico. With scale.
 Pen and grey wash (360×450).
 Watermark.

Like the preceding sheets, this is in the same hand as those of 194–207. The plan,
C, seems to be based on Bartoli's reconstruction of Alberti's Tuscan Temple (see *L'Archi-
tettura di Leon Batista Alberti Tradotta . . . da Cosimo Bartoli*, vii. 157). Jones and sub-
sequently Webb owned a copy of this book. As a design, it may be compared with
146, 151 and the portico of St. Paul's Covent Garden.

168A–C (Gotch 1/52)
 Plan, elevation, and longitudinal section of a Roman house.
 Pen and ink (505×365).

These drawings are almost exact copies of Scamozzi's Casa de' Senatori Romani and
Casa Antica Romana (Scamozzi, I. iii. 234 and 235). Scamozzi's design was itself
modelled on that by Palladio for a Greek house (see 239). Webb's drawings of the
elevation and section, B and C, are Scamozzi's illustrations in reverse.

169 (Gotch 1/58)
 Plan and elevation for a villa with portico of five bays. With scale.
 Pen and grey wash (480×365).
Reprd.: W. G. Keith, 'Inigo Jones as a Collector', *RIBA Journal*, xxxiii (1925), Pl. 9.

This is a copy by Webb of a scheme for an unknown villa by Palladio in
RIBA BD XVII/16 (see Giangiorgio Zorzi, *Le Ville e i teatri di Andrea Palladio*
(Venice, 1969), p. 45).

170A–B (Gotch 1/59) (Pl. 114)
 Sectional elevation and part plan of a Palladian basilica. With scale.
 Pen and ink with pencil (405×310).
 Watermark.

This and the following sheet, 171, are closely inspired by Palladio's basilica at Vicenza,
and particularly by his second project. See Catalogue: *Andrea Palladio* (London,
1975), p. 31. The left elevation of drawing A reappears on sheet 171 and also in the
piazza drawing, 193. There are blue-ink additions of corner staircases on plan B.

171A–B (Gotch 1/60)
 Two part-elevations of a Palladian basilica.
 Pen and ink with pencil (200×305).
 Watermark.

The left half-elevation is a copy of 170A with the pencilled additions of sculpture on the balustrade: the courtyard elevation, B, differs in height from that given in 170. A is loosely based on Palladio's second project for the basilica at Vicenza (RIBA BD XIII/9).

172A–M (Gotch 11/62) (Pl. 115)
Four plans and nine elevations for small houses.
 Insc.: (H) *Serl lib. 4: fo | 166b*
 (K) *office of ye | works at | Newmarkett.*
 Pen and ink with pencil (305×430).
 Watermark.

Reprd.: (K) John Harris, 'Inigo Jones and the Prince's Lodging at Newmarket', *Architectural History*, 2 (1959), Pl. 11.

The elevation H, derived from Serlio, shows several modifications. The three drawings for the Newmarket house, J–L, are similar to those given in Le Muet's *Manière de bien Bastir* (1623), as is M.

173A–U (Gotch 11/63) (Pl. 116)
 Twenty-one plans for villas.
 Pen and ink with pencil on scored paper (300×395).
 Watermark.

Reprd.: (J, K, R, S, T, U) W. G. Keith, 'Inigo Jones as a Collector', *RIBA Journal*, xxxiii (1925), Pls. 2, 5.

Most of these plans are after either the woodcuts of *I Quattro Libri* or the Palladian drawings that Jones owned. Plan F is the main block of the villa Mocenigo at Dolo, Plan I is after a Palladian drawing (RIBA BD XVI/5 recto), similarly Plan K (BD XVI/13), Plan R (BD XVI/8), and Plans S–U (BD XVI/12). Plan J is a copy of a drawing, possibly by Palladio, in the same collection XVI/5.

This sheet, that of 181, and a similar one, RIBA BD V/5, complement each other and together compose the remains of a broken set. In this type of plan study Webb may well have been inspired by a similar sheet of drawings by Palladio in

RIBA BD XI/22 verso. These plans were presumably made on scored paper to be readily enlarged by the use of the sector or joint rule. This was probably true of 172 and 176–81.

174A–B (Gotch 11/63 verso)
 Two plans for courtyarded villas.
 Pen and ink with pencil (300 × 395).
 Watermark.

These two villa plans are variations on a smaller scale drawing, RIBA BD V/3. It is also in Webb's hand.

175A–H (Gotch 11/64)
 Three elevations, three sectional elevations, and details of villas.
 Insc.: (A) *ye head of this wyndow lyes not even | with ye Rustick.*
 Pen and ink with pencil (305 × 390).
 Watermark.

Reprd.: (A, D, H,) W. G. Keith, 'Inigo Jones as a Collector', *RIBA Journal*, xxxiii (1925), Pl. 10.

All these designs are clearly derived from Palladio—either from *I Quattro Libri* or from Jones's collection of Palladian drawings. Drawing B is based on the Villa Thiene at Cicogna, and E is the centre block of the Villa Emo at Fanzolo. The half-elevation, H, is after the Palladian drawing, RIBA BD XVII/25, for the Villa Antonini, Udine, as are A and D, see Palladio, ii. 5. It is also worth comparing them with Palladio, ii. 15, the Villa Garzadori, see 179. C may be after the centre block of the Villa Porta, Vivaro di Dueville, see Puppi, *Andrea Palladio* (London, 1975), pp. 297–8.

176A–D (Gotch 11/65)
 Four plans.
 Pen and ink with pencil on scored paper (305 × 390).
 Watermark.

The largest plan, B, is a copy by Webb of the plan of the Villa Maser (Palladio, ii. 51). The plan above, A, may be derived from that of the nymphaeum at Maser or be after the loggia of the Villa Madama. The rustic column is similar to that found at Palladio's Villa Sarego, near Verona, or in the work of Sanmicheli. Plan D is a copy of a project by Palladio (RIBA BD XVI/8).

177A–C (Gotch 11/65A)
 Three villa plans.
 Insc.: (A) *This Court of ye same length as yt behind | that hath Arches this none & ye entrance from | house. ye other syde of | ye Court answerable | to this.*
 Pen and ink with pencil, on scored paper (305×380).
 Watermark.

Plans A and B may be based on the rough sketch by Palladio for the Villa Mocenigo at Dolo, which was probably owned by Jones (RIBA BD XVI/1 and 2). The idea expressed in these two plans of a bridge between courts may well be related to Jones's Queen's House at Greenwich. Plan A is also similar to an unidentified one by John Thorpe (see John Summerson, 'The Book of Architecture of John Thorpe', *Walpole Society*, xl (1966), Pl. 22, T 32). C may be a version of BD XVI/4 recto, a study for the ground plan of the Villa Poiana.

178 verso (Gotch 11/65A verso)
 Plan of small rectangular villa with four-bay portico.
 Pencil (305×380).

179A–E (Gotch 11/65B)
 Elevation and four villa plans.
 Insc.: (C and D) *ground roomes upper roomes*
 (E) *Dove house*
 Pen and ink with pencil, on scored paper (305×390).
 Watermark.

The main block of plan A is loosely based on Palladio's design for the Villa Garzadori (Palladio, ii. 77). The small plans and elevation, C–E, may be connected with Jones's design for the Brew House at Newmarket (see John Harris, 'Inigo Jones and the Prince's Lodging at Newmarket', *Architectural History*, 2 (1959), p. 33).

180A–H (Gotch 11/65C)
 Eight house plans.
 Insc.: (A) *The stayre is enterd uppon at J: | & ye Ascent beginns at S | & you enter into ye hall above | at T. aforesayd & if you would make ye Hall | broader to ye letter B. ye sayd | entrance into ye Hall wilbe | in ye middle thereof but then | it must have light from G but observe yt if ye hall bee | made greater it wilbe spoyle | ye proportion of ye Chambers | D: a passage serveth from | one chamber to another.*
 Pen and ink with pencil, on scored paper (305×385).
 Watermark.

Plans A and G are practical schemes, carefully worked out as Webb's notes show. The other drawings seem much more academic in purpose, B, C, and D, being exercises in the arrangement of the kitchen, hall, parlour, and study, in small houses.

181A–Y (Gotch 11/65D) (Pl. 117)
 Twenty-five plans for villas and palaces.
 Pen and ink with pencil (370×470).
 Watermark.

Webb has annotated the sources for these redrawings: C is after Philibert de l'Orme, D–F and J–L after Viola Zanini, A–B, S, T, V–X after Rubens's *Palazzi di Genova*, G, N, Y are copied from Serlio. Plan P is noted 'Antonio St Gallo' and is probably a copy of a Sangallo drawing that Jones knew or owned, possibly that for the villa Cervini al Vino (see Giovannoni ii. 321). O and R are ground- and first-floor plans of Sir Peter Killigrew's house in London, designed by Jones, for which Webb gave window details on 190 verso and for which there is an elevational drawing in his hand. Two other drawings are noted by Webb as the plans of 'Mr. Surveyor' and V may be compared with the plan of Stoke Bruerne attributed to Jones. Like sheet 173 few are accurate copies of the original.

182A–H (Gotch 11/66)
 Seven designs for doorways and a monument.
 Pen and ink with pencil (305×380).
 Watermark.

Doorways A–C are inscribed below, 'Dorick', 'Ionick', and 'Corinthian'. The half-elevation of a gateway, D, is a copy of a rustic doorway, attributed by Zorzi to M. A. Palladio, in RIBA BD XIII/3. E–G are copies of XV/3 in that collection. H is perhaps a free copy of Palladio's drawing for the Gritti Monument in S. Francesco della Vigna (see Giangiorgio Zorzi, *Le Chiese e i Ponti di Andrea Palladio* (Venice, 1967), pp. 33–4). There is a thumb-nail sketch of this in a sheet of plans for the Baths of Agrippa, RIBA BD VII/6 verso.

183A–C (Gotch 11/67)
 Elevation of five-bay building, detail of arcade, and elevation of an apsidal daïs and throne.
 Pen and ink with additions (pencil) (305×390).
 Watermark.

The elevation, B, may possibly be derived from the Doric and Ionic storeys of Palladio's courtyard for the Convent of the Carita, in Venice. The width of a bay—9 feet—certainly tallies with that given in *I Quattro Libri*. A is a copy of the Palladian drawing in RIBA BD XVII/20 recto, for a Venetian barn attributed to M. A. Palladio (see Zorzi, *Le Ville e i Teatri di Andrea Palladio* p. 50). C is without doubt a copy of Palladio's design for the daïs and throne in the Sala del Collegio in the Palazzo Ducale, Venice.

184A–H (Gotch II/68) (Pl. 118)
 Eight drawings of arches, arcades, and their details.
 Insc.: *Arch in Verona*
 This is measured by ye | Ancient foote.
 Pen and ink (305 × 390).
 Watermark.

Reprd.: (E, F, G) W. G. Keith, 'Inigo Jones as a Collector', *RIBA Journal*, xxxiii (1925), Pl. 2.

A is a reduced version by Webb of an identical but larger drawing by him in the Salvin Collection, RIBA, Webb/173, illustrated in Harris *Catalogue . . . Inigo Jones and John Webb*, fig. 175. Drawings E–G of the 'Arch in Verona' are copies of Palladio's drawing of the Arco di Giove Ammone, in Verona, RIBA BD XII/22. See Spielman *op. cit.*, p. 171.

185A–B (Gotch II/69)
 Two elevations of two triumphal arches.
 Pen and ink (305 × 390).
 Watermark.

A is copied from a Palladian drawing in RIBA BD VII/13 verso, which may have belonged to Jones. It is possibly a study for the Arco delle Scalette, Vicenza B is similar to the triumphal arch in Serlio, iv. 181.

186A–C (Gotch II/70)
 An arcade and two arched doorways.
 Pen and ink (305 × 390).
 Watermark.

The arcade, A, is similar to that shown on 184 D though with the addition of an extra bay on either side. The gateway, C, is similarly a version of the Corinthian gate on

184; both may be compared with the centre opening of Jones's Winchester Cathedral choir screen of 1638 (see Harris, *Catalogue . . . Inigo Jones and John Webb*, p. 17). The doorway, B, is close to the style of Nicholas Stone's Great Hall doorway at Kirby in Northamptonshire *c.*1638.

187A–D (Gotch 11/71)
 A seven-bay elevation and three window elevations. With scale.
 Pen and ink with pencil (210 × 305).
 Watermark.

Webb's reference to Serlio below C, 'Serlio lib. 3. fo: 89: b: & 90: a' is incorrect. This window and that of A are similar to those used by Jones at Whitehall and in the Star Chamber schemes, and are themselves related to those of the Palazzo Thiene and so to the work of Guilio Romano. A is closely derived from an early elevation of Palladio's (RIBA BD XVII/2 recto), and the elevation B is a free copy of Palladio's design for a Villino con Loggia (RIBA BD XVII/27), associated with the Villa Gazzotti at Bertesina.

188A–T (Gotch 11/72) (Pl. 119)
 Eleven plans and nine elevations for small churches.
 Insc.: *private Chappels for pallaces or otherwise.*
 Pen and ink with pencil (370 × 465).
 Watermark.

Nearly all these drawings are after the illustrations to Serlio's Libro Terzo, and may also be inspired by similar drawings after Serlio by Palladio, RIBA BD VIII/7, which bear Webb's annotations. J–L are ways of elevating the façade of St. Peter's following the designs of Bramante and Peruzzi, see plan G on verso. The façade drawing A is adapted from Serlio, iii. 64, with a plinth and sculpture added, and may be associated with Jones's Hale Church of 1631–2, see also 146. The note to 'Serl. lib. 4 fo: 147' supplies the source for the plinth of the building. The plan at I is an ink version of the pencil plan A. Drawing C, and the related section below, F, may be compared with Webb's work on the Vyne pavilion or that of Jones (?) on a similar structure at Bedford House, London (see A. C. Downs, 'Inigo Jones's Covent Garden: The first seventy-five years', *Journal of the Society of Architectural Historians* (1967), pp. 30–1). The centralized plan, O, is noted by Webb as 'This church hath / foure entrances & ye / Communion Table / stands (Altar) in ye middle / at ye foure Corners / there may bee vestryes / & over them ye belfryes / especially in front & / over ye Loggias / may bee galleryes'.

189 verso A–G (Gotch 11/72 verso)
 Six part-plans and one section of small churches.
 Pen and ink with pencil (370 × 465).

Like 188, of which this is the verso, these plans are derived from Serlio. They are all taken from either the Libro Terzo or Quattro. Plan A is that of Bramante's Tempietto, B one of the ruins near the theatre at Ferento, C a chapel at Jerusalem, for which Webb gives at E a conjectural restoration. G is a detail of Bramante's plan for St. Peter's.

190A–Q (Gotch 11/73) (Pl. 120)
 Seventeen elevations of windows and notes.
 Insc.: *vide doores wyndowes, etc.*
 (A) *In ye front | where wyndowes | are made wth | pillars or pilast | it might bee | observed yt the | bases capitall | of them must bee | of another | Invention & | of less ornamt | then ye bases | Capitall | of ye principall | Columnes of ye front | yett neverthelesse ye | same order must bee | always observed Serl: lib 3 fo: 112*
 (J) *The middle space of | this wyndow is twice | as much as ye syde | spaces: ye Col a: is but 1/2 a diameter: therefore | these manner of wyndowes | should have ye syde | spaces not lesse then 1/2 | ye middle space nor | more then. And these manner of | wyndowes may bee used | where ye buildings | stand in narrow & streight | places so yt ye roomes may | have ye greater light.*
 Pen and ink (370×470).
 Watermark.

These drawings are mostly taken from Serlio, though A cites rather ambiguously both 'Pall: fo: 82' and 'Serlio: fo 55'. Most of the drawings are adaptations rather than copies. A and B are based on the blind niches of the Pantheon, D is taken from the centre bay of Constantine's arch, and M is a doorway from Serlio turned into a window.

191 verso A–J (Gotch 11/73 verso) (Pl. 121)
 Ten elevational drawings of windows.
 Insc.: (A) *St. James's*
 (B, C) *Serlio fo 46: ibm*
 (D, E) *wyndowes of ye stayrecase | at Sr. P: Killigrews house | Blackfryers Mr Sury^{rs} designe*
 (F) *Wyndowes of ye | first story ibm*
 (H) *how ye | moulding | wch continues | under ye eaves | of ye Roofe | adornes | ye head of A: moulding under | ye wyndowe: ye Roofe | Newmarkett: Brewhouse.*

(I) *At Newmarkett the principall | cornice of ye front is on ye | syde backwards towards ye Court converted into 2: | fascias*
& those fascias break | as in this schitzo: to give way | to ye lights of ye halfe story.
Serl'lib: 4: fo: 130: b.
Pen and ink with pencil (370×470).
Watermark.

Reprd.: (H) John Harris, 'Inigo Jones and the Prince's Lodging at Newmarket', *Architectural History*, 2 (1959), Pl. 2.

It is probable that many of Webb's copy drawings were derived not only from Jones's own designs but also from his copies after the Italian theorists. B and C are directly inspired by Jones's drawing after Serlio, executed in 1618 (see RIBA BD II/18 A–C; Wittkower, 'Inigo Jones, Architect and Man of Letters', *RIBA Journal* (1953), 83–4). A is a copy of a window at Jones's St. James's, either the Prince's Buttery (1617–18), or the water front of the palace. It could also be from his later work at the Pergola and Withdrawing Room of 1629. For D and E see 5 and 6.

192A–D (Gotch 11/74)
 Four windows.
 Insc.: *wyndowes.*
 Pen and ink (370×470).
 Watermark.

A and B are noted 'P:P:R: /fig. 6' and 'P:P:R: /fig. 11'. Both are amended copies after Rubens's Palazzi Antichi in the *Palazzi di Genova*. This sheet, like 190 and 191 was probably part of the illustrated section of Webb's manuscript treatise on windows (see 232–4).

193A–H (Gotch 11/75)
 Five plans, three elevations, and notes for 'Exchanges or Merchants Piazzas'.
 Insc.: *Exchanges or Merchants Piazzas.*
 Pen and ink (235×365).

This sheet may be compared with 170 and 171, which are variants of Palladio's basilica at Vicenza. The top plan, A, seems to be derived from Serlio's Portico di Pompeo (see Serlio, iii. 75), and from the Palladian drawing (RIBA BD X/1). Its architecture has little in common with Jones's piazza at Covent Garden Piazza begun in 1631. B (left) was, according to a note, a 'designe may serve for a | Royall Exchange for a |

metropolis as London & ye like'. It is thus a theoretical drawing, a flexible solution where, as Webb notes on plan E, 'if ye worke / fronts but uppon / one streete then / ye invention may / bee according to / this designe'. H is a small-scale interpretation of 170 and 171.

194–7 (Gotch 11/77–77C) (Pl. 122)
 Two elevations and two sections through a peripheral temple.
 Pen and grey wash (95× 120).
 (95× 160).
 (100× 180).
 (85× 120).
 Countermark (197).

These four drawings were originally part of one sheet similar to 201. They, and 198–207, are in the same hand and technique. It is likely that all are essays in the reconstruction of Vitruvian temple forms and were probably derived from Rusconi's illustrations to his *Della Architettura* (1590). A copy of this book was owned by both Jones and Webb and these drawings may well be based on Rusconi, iii. 50. Of the series of temple forms only that for the amphiprostyle appears to be missing. Curiously, this temple was used in the Ionic form by Jones for his second Temple of Diana, in the masque of Florimiène in 1635 (see Catalogue, *King's Arcadia*, fig. 305).

198 (Gotch 11/77D)
 Plan of a hypaethral dipteral temple. With scale.
 Pen and grey wash (305× 430).
 Countermark.

Like 199 and 200, this is a reconstruction of the temple described in Vitruvius, iv. iii. There is an account of it in Rusconi, iii. 53. The character of such temples was important to Webb's argument on the porticos which he advanced in *The Most Notable Antiquity of Great Britain called Stone-Heng, Restored* (1655), and in his expanded *A Vindication of Stone-Heng, Restored* (1665).

199A–B (Gotch 11/77E)
 Elevation and longitudinal section of a hypaethral dipteral temple.
 Pen and grey wash (305× 430).
 Countermark.

This is the longitudinal section and elevation of 198. On an annotated drawing by Webb, 160, there are two pencil and unfinished versions of both the section A and elevation B.

200A–B (Gotch 11/77F)
Elevation and latitudinal section of a hypaethral dipteral temple.
Pen and grey wash (305×430).

This is the latitudinal section and elevation of 198.

201A–D (Gotch 11/77G)
Two elevations and two sections of a pseudo-dipteral temple.
Pen and grey wash (310×430).
Countermark.

Like the preceding drawings, 198–200, these are probably based on Rusconi's interpretation of the Vitruvian temple, is this case pseudo-dipteral (see Rusconi, iii. 51). Nos. 204–7 are variations upon this temple form.

202A–E (Gotch 11/77H)
Plan, two elevations, and two sections of a distylar temple. With scale.
Insc.: (in pencil) (B) *To make these pilasters | not to diminish | & without cartooses on ye | cornice.*
Pen and grey wash (310×43).
Countermark.

This is a further reconstruction of the Vitruvian temple with portico *in antis*, probably after Rusconi, iii. 49. The pencil annotation is in the hand of John Webb.

203A–E (Gotch 11/77J)
Plan, two elevations, and two sections of a prostylar temple. With scale.
Pen and grey wash (310×430).
Countermark.

Like 202 and the preceding drawings this is a reconstruction of the Vitruvian prostyle temple, probably after Rusconi, iii. 49.

204–7 (Gotch 11/77K–11/77N)
 Two elevations and two sections of a pseudo-dipteral temple.
 Pen and grey wash (105 × 140)
 (100 × 260)
 (100 × 260)
 (105 × 140).
 Countermark (207).
These are a variation upon 201. The designs differ in the form given to the inner sanctuary and in the scale of the building. Like 194–7, the original sheet has been dismembered.

208 (Gotch 11/78$^1$)
 Elevation of a Corinthian doorway.
 Insc.: *Corinthian order.*
 Pen and ink (360 × 510).

Presumably part of Webb's studies on this order (see 216–19). It may be compared with Jones's design for a gateway to New Hall, Essex, of 1629 (RIBA BD) II/1 (1)).

209 (Gotch 11/78$^2$)
 Elevation of a Composite doorway.
 Insc.: *Composito order.*
 Pen and ink (360 × 510)
 Countermark.

Part of the same series of drawings as 208 and associated with Webb's drawings for the Composite order, 214 and 225. It is a rusticated version of Jones's drawing in the RIBA for an arched entrance with masonry surround rusticated on the sides (see Harris, *Catalogue . . . Inigo Jones and John Webb.*, p. 18, Fig. 83).

210 (Gotch 11/78$^3$) (Pl. 123)
 Capital and details of the Ionic order. With scale.
 Insc.: *5* and *Ornament of the Ionick Order with Dentyles in the Cornice.*
 Pen and ink (360 × 255).

This sheet, like 211, is based upon Palladio's reconstruction of the Ionic order rather than that of Scamozzi (see Palladio, i. 36). It shows the volutes of the Ionic capital

as straight instead of turning outwards. Webb notes this as illustrating 'in what manner the volutes of the Pilaster Capitall comes forth whereby by ye ovolo is made to lye agt it'. A capital plan, similar to that shown by Webb, is given in Vignola, *Regole delli cinque Ordini d'Architettura* (1562), Pl. XVIIII.

211 (Gotch 11/783ª)
 Capital and details of the Ionic order.
 Insc.: *6* and *Ornament of ye Ionick order according to ye division of the Cartooses | by 32: minutes ½ whereby the intercolumne falls out to bee inst 2: mod: ¼*
 Pen and ink (360×255).

Reprd.: R. Wittkower, 'Inigo Jones, Architect and Man of Letters', *RIBA Journal* (1953), p. 86.

This is a variation upon the design of the Ionic capital. Like 210, it is based on Webb's redrawing from Palladio, i. 36.

212A–D (Gotch 11/784ª)
 Four drawings for a keystone in profile and elevation.
 Insc.: (A) *8* and *Keystone of the greater | Arch in ffront*
 (B) *Purfyle of that Keystone*
 (C) *Keystone of ye lesser | Arch in ffront*
 (D) *Purfyle of that | Keystone*
 Pen and ink with pencil (360×255).

These four drawings may be inspired by the 'ornamenti' for the Corinthian order given by Scamozzi, II. vi. 162. There are similar designs for the Composite and Corinthian orders on 215 and 217 respectively. The profile at B is an addition superimposed on a similar drawing.

213 (Gotch 11/78)
 Capital and details of the Ionic order. With scale.
 Insc.: *7* and *In what manner ye Pillasters with Angular volutes in ye Capitall are to ioyned together.*
 Pen and ink (360×255).

A further variant of the Ionic from Palladio.

214 (Gotch 11/78⁵)

Unfinished plan and elevation of a Composite capital.

Insc.: *Composito capitall the | Columne being 9: diameters high.*

Pen and ink (360×255).

This is an unfinished version of the capital and plan given in 225. Like it, this drawing is probably based on Scamozzi, II. vi. 118.

215A–D (Gotch 11/78⁵ᵃ)

Four drawings in elevation and profile for a keystone of the Composite order.

Insc.: *Composito Order*

(A) *Keystone of the greater | Arches*

(B) *Purfyle of that Keystone*

(C) *Keystone lesser Arches*

(D) *Purfyle thereof.*

Pen and ink (360×255).

This sheet, like 212 and 217, may be inspired by the console design given in Scamozzi, II. vi. 162. All are part of Webb's series of drawings on the various orders.

216 folded A–B (Gotch 11/78⁶ᵃ)

Two plans and two elevations of a Corinthian capital, all incomplete.

Insc.: *Corinthian Capitall:*

Pen and ink (360×255).

The plan and elevation, A, follow Scamozzi, II. vi. 138 closely. The lower drawing, B, is a different view of the same capital which is not shown in Scamozzi. The two drawings are early versions of 219.

217A–D (Gotch 11/78⁶)

Four drawings in elevation and profile for a keystone of the Corinthian (?) order.

Insc.: (A) *Keystone of the | greater Arches*

(B) *Profyle of yt key=|stone:*

(C) *Keystone lesser | Arches*

(D) *Profyle of that | Keystone.*

Pen and ink (360×255).

This sheet, like 212 and 215, is probably derived from Scamozzi, and is part of a similar series of studies on the orders.

218 (Gotch 11/78⁷)
 Elevation, plan, and details of the base of the Corinthian order.
 Insc.: *Plant of the base:*
 Corinthian Pedestall:
 Pen and ink (360×255).

This, with 216, is part of Webb's series of academic drawings on the Corinthian order. This sheet is probably based on Scamozzi, II. vi. 135 though with several minor alterations. A flap has been superimposed on the top of the dado of the pedestal.

219 (Gotch 11/78) (Pl. 124)
 Capital, architrave, freize, and cornice of the Corinthian order.
 Insc.: *Ornament of the Corinthian order*
 (pencil) *The leafe at the Angle | must bee* . . . (illegible).
 Pen and ink (360× 255).

This is a modified copy of Scamozzi, II. vi. 138. It is a partly finished version of 216.

220 (Gotch 11/78⁸ᵃ)
 Elevation of a cornice, freize, and architrave.
 Pen and ink (385×260).

This drawing is close to the style of draughtsmanship of a series of entablature and capital studies (see RIBA BD XII/18 verso and XII/19). These are attributed by Zorzi to Falconetto but seem close to similar drawings by Palladio. (Giangiorgio Zorzi, *I Disegni delle Antichità di Andrea Palladio* (Venice, 1959), p. 49).

221 (Gotch 11/78⁹)
 Capital, architrave, frieze, and cornice of the Ionic order, With scale.
 Insc.: *4* and *Ornament of the Ionick order:*
 Pen and ink (370×255).

Reprd.: R. Wittkower, 'Inigo Jones, Architect and Man of Letters', *RIBA Journal* 1953), p. 86.

Part of Webb's series of drawings of the classical orders. It seems to be based on Scamozzi, II. vi. 101, 'Ornamenti del orde Ionico', though with several minor alterations. 210 and 211 are variations upon this design though with straight rather than angled volutes.

222 (Gotch 11/789ª)
 Elevation, plan, and details of the base and pedestal of the Ionic order.
 Insc.: *3* and *Ionick Pedestall.*
 Pen and ink (360×255).

This is a copy, with modifications in detail, of Scamozzi's 'Parti Inferiori del Ordine
Ionico', Scamozzi, II. vi. 97.

223 (Gotch 11/78¹⁰)
 Capital, architrave, frieze, and cornice of the Doric order. With scale.
 Insc.: *9* and *Ornament of the Dorick order.*
 Pen and ink (360×255).

This sheet is closely modelled on Scamozzi, II. vi. 84—'Ornamo del ordine dorico'.
The fleur-de-lis decoration of the one metope shown is completely different from that
given by Scamozzi or the traditional bucranium of Palladio, i. 27. It derives instead
from Vignola and his Porta degli Orti Farnesiani.

224 (Gotch 11/78¹⁰ª)
 Elevation, plan, and details of the base and pedestal of the Dorick order.
 Insc.: *3* and *Dorick Pedestall:*
 Pen and ink (360×255).

Like 223, this sheet is modelled on Scamozzi's illustrations of Doric order, in this case
Scamozzi, II. vi. 81. There are several minor variations in detail and proportion. Webb's
notes are a translation of those of Scamozzi.

225 (Gotch 11/78¹¹)
 Capital, architrave, frieze, and cornice of the Composite order. With scale.
 Insc.: *Ornament of the Composito Order.*
 Pen and ink (360×255).

This is probably taken from Scamozzi's 'Ornamt del' orde Romo' (Scamozzi, II. vi.
118). There are several modifications, particularly in Webb's drawing of the architrave
and in the plan and half-plan of the capital. His proportions differ slightly from those
given by Scamozzi, 40 minutes against Scamozzi's 39, 30 against $31\frac{1}{4}$, and 50 against
$46\frac{3}{4}$. Sheet 214 is a similar but incomplete version of this capital.

226 (Gotch 11/78$^{11a}$)
Elevation and details of the base and pedestal of the Composite order.
Insc.: *Composito Base*:
Pen and ink (360×255).

Like 225, this is taken from Scamozzi on the Roman or Composite order and is probably a copy after Scamozzi, II. vi. 91. It varies from its source in detail and in proportion.

227C–230H (Gotch 11/78$^{12}$— 78$^{15c}$ verso)
Seventeen sheets, 'of the Ionick order' manuscript.
Pen and ink (370×255) and (310×190)
Several watermarks.

Webb's notes on the Ionic order were possibly made in imitation of Freart's *Parallele de l'Architecture antique avec la moderne*, which first appeared in 1650. However, their practical use can be seen in both his edition of Jones's *The Most Notable Antiquity of Great Britain called Stone-Heng, Restored* (1655), and his *Vindication of Stone-Heng, Restored* (1665), where he gave a dazzling display of classical erudition. The manuscript may be divided roughly into two parts: that on the order itself, 230A–H, and that on the use of the order, 227C–D, 228A–D, and 229A–B. The rather repetitive notes are derived from Scamozzi's treatise on the Ionic order (see Scamozzi, II. vi. 85–100), and complement Webb's drawings of the Ionic order (see 221 and 222). Webb also refers to Books Three and Four of Vitruvius on 229A. Several of the pages, 227C, 228A, 228C, and 229A, are numbered 9 to 16 on the top right in a hand which is more likely to be that of John Talman than Webb. Folios 228A–D, 227C–D, and, to some extent, 229A–B, are repetitions of one another in content though none are transcriptions. 227C is typical in its range of subject-matter:

Arches with | Columnes uppon | pedestalls
Compartiment
how farr the Columns | stand forth of ye wall
Pilaster in ffront | in Thicknesse
Alette or Membretts
height and bredth of | the Arches
height of ye Keystone
forme of ye Arch:
Impost
Archivolt
Keystone in bredth
how the Cartooses | fall out:

Alette at the Quoynes | diminish:
Principall Gate
height & bredth of ye | dore
ornament of ye dore.

230A–H are concerned by and large with the more detailed aspects of the order, the proportioning of the capital, the frieze, etc. On 230G, Webb sums up, 'The Ionick order hath in it all these points yt are comely gracious & beautiful for it imitates ye gravity of Matrons & Solemme women'.

231A–233B (Gotch 11/78$^{16}$) (Pl. 125)
 Six sheets of a manuscript 'of wyndowes'.
 Pen and ink (360×230).
 Several watermarks.

These sheets are numbered by Webb 161 to 166 and are probably part of a series of notes he made on classical architecture. His treatise on the Ionic order, 227C–230H was probably a further part of this work. His statements are taken principally from Scamozzi but also from Viola Zanini, Serlio, and Alberti. His page references make it quite clear which edition of these authors he employed; and the books themselves are probably those preserved in the library at Worcester (see E. H. Wilkinson, 'Worcester College Library', *Oxford Bibliographical Society*, i (1923), pp. 305–8). Webb's essay deals principally with the problems of window design and construction which may be summarized as follows:

 Page 161 The various types of window, their proportion, and composition.
 Page 162 Webb divides this into 'height of wyndowes', 'Breadth of ye wyndowes', and 'Bastard wyndowes'.
 Page 163 The uses and effect of light and sunlight.
 Page 164 Webb deals here with 'In wt manner wyndowes are to bee wrought & sett'.
 Page 165 The construction of windows.
 Page 166 The relationship of the windows to the proportion of the rooms they light with the example of the Pantheon. A small drawing in the margin of part of the interior of the Pantheon is noted 'wyndowes / over ye / chappell'.

234A–C (Gotch 11/unnumbered)
 Plan, elevation, and section of a house with a Corinthian atrium. With scale.
 Insc.: *The Corinthian Atrium is in length*, etc.
 Pen and ink (365×505).

In *I Quattro Libri* Palladio discussed this form of design and illustrated it with his Convent of the Carita in Venice (Palladio, ii. 29), where he 'a quelle de gli Antichi: e pero io ho fatto L'Atrio Corinthio'. This type of atrium also appeared in his illustrations to the Barbaro Vitruvius (1556), and it may be from it that Webb's drawings are derived. Its descendant is shown in his designs for a three-storeyed palace in the RIBA (see Harris, *Catalogue . . . Inigo Jones and John Webb*, p. 27, figs. 196–8). Webb's own and interleaved Palladio at Worcester carries his notes on the dimensions of the atrium of the Carità (see Palladio, ii. 30–1).

235 (Gotch 11/unnumbered)
 Part plan of a house with a Tuscan atrium.
 Insc.: *The Ground platt of ye Tuscane Atrium:*
 Pen and ink with pencil (360×250).

This is taken, with minor modifications, from Palladio's Atrio Toscano (Palladio, ii. 26). *See also* 238.

236A–C (Gotch 11/unnumbered)
 Part plan, elevation, section, and notes on a house with an atrium of four columns. With scale.
 Insc.: *This designe hath the Atrium of foure Columnes*, etc.
 Pen and ink (365×505).

The plan, A, and section, B, are closely derived from Palladio's Atrio di Quattro Colonne (Palladio, ii. 28). The elevation that Webb provides, with a Palladian portico reduced from five to three bays and façade divided by semi-engaged Corinthian and Ionic columns, is taken from Palladio's plan. The notes are a translation of the commentary on page 27. A form of this atrium appears in Webb's Whitehall plans (see 28–56).

237A–C (Gotch 11/unnumbered)
 Plan, elevation, section, and notes on a house with a 'Testugginato' atrium. With scale.
 Insc.: *The Atrio Testugginato or covered Atrium was much in use among the Ancients*, etc.
 Pen and ink with pencil (365×505) (folded).
 Countermark.

Like 235 and 236, the plan, section, and notes are taken closely from Palladio, in this case Palladio, ii. 35, the elevation being largely Webb's own interpretation.

238 (Gotch 11/unnumbered)
　　Elevation, section, and notes on a house with a Tuscan atrium.
　　Insc.: *The designe is of the Tuscane Atrium*, etc.
　　Pen and ink (360×250).

Like 235, the section is closely copied from Palladio, ii. 26. The elevation is probably
Webb's own interpretation. The various notes are a translation of those of Palladio
on page 24.

239A–B (Gotch 11/unnumbered)
　　Plan and longitudinal section of a Greek house.
　　Insc.: (A) *Groundplatt of ye house of ye principall Graecians*
　　　　　 (B) *The Aspect within of ye Graecian house.*
　　Pen and ink (365×500).
　　Countermark.

These two drawings are almost exact copies of Scamozzi's Casa Greca (Scamozzi,
I. iii. 228 and 229). Scamozzi's design itself is a more elaborate version of Palladio's
Case Private de'Greci (see Palladio, ii. 44).

240 (Gotch 11/unnumbered)
　　Elevation and plan of a three-bay portico of the Tuscan order.
　　Insc.: *11.*
　　Pen and ink (360×255).

This is probably a copy of Scamozzi's 'Aspetto del colonnato Toscano' (Scamozzi,
II. vi. 58). The mutules on the pediment do not appear in Scamozzi and are probably
taken from Palladio's illustrations to Barbaro's Vitruvius. The sheet, like 146, may be
associated with Jones's work at St. Paul's Covent Garden of 1631 (see John Summerson,
'Inigo Jones', *Proceedings of the British Academy*, i (1964), p. 175).

241 (Gotch 11/unnumbered)
　　Elevation and plan of a three-bay portico of the Doric order.
　　Insc.: *8.*
　　Pen and ink (360×255).

This is probably taken from Scamozzi, II. vi. 73. It differs from Scamozzi's illustration
in the decoration of the frieze where Webb leaves out the traditional bucranium. It is a
companion to 240 on the Tuscan.

242 (Gotch 11/unnumbered)
 Plan and elevation of a three-bay Ionic portico.
 Insc.: *10* and *Aspect of the manner Enstilos with Dentyles in the | Cornice:*
 Pen and ink (360×255).
 Countermark.

This is a version of 245 and based on Scamozzi, II. vi. 89. However, it uses the Palladian form of the Ionic where the volutes do not turn outwards as they do in Scamozzi. The pediment also contains dentils rather than the mutules shown in Scamozzi.

243 (Gotch 11/unnumbered)
 Plan and elevation of a three-bay Ionic portico.
 Insc.: *11* and *Aspects of the manner Enstilos with Cartooses in the Cornice.*
 Pen and ink (360×510).

Like 244, this is probably based on Scamozzi, II. vi. 89. But unlike 242, the cornice has mutules rather than dentils. The form of Ionic is, however, the same.

244 (Gotch 11/unnumbered)
 Plan and elevation of a three-bay Ionico portico.
 Insc.: *10.*
 Pen and ink (360×255).

This is possibly a copy of Scamozzi's 'Aspetto del Colonnato Ionico' (Scamozzi, II. vi. 89). It shows differences in the pediment of the doorway and in the string course. 248 is a more accurate copy of this illustration.

245 (Gotch 11/unnumbered)
 Plan and elevation of a three-bay Ionic portico.
 Insc.: *13.*
 Pen and ink (360×255).

Like 244, this is a copy of Scamozzi, II. vi. 89. It varies only slightly from the prototype. However, apart from the note: 'mod: 4: min: 18:', Webb showed little interest in Scamozzi's modular system for the Ionic, $8\frac{3}{4}$ of the ideal 10, nor did he directly refer to it in his manuscript on the Ionic order (see 227C–230H). The Ionic capital with projecting volutes used here and in 244 differs from that given in 242.

246 (Gotch 11/unnumbered)
　　Plan and elevation of one and a half bays of an Ionic loggia.
　　Insc.: *19.*
　　Pen and ink (360×255).

This drawing, and that of 248, is probably based on Scamozzi, II. vi. 91—'Aspetto de gl archi Ionici'. The pedimented doorway does not appear in Scamozzi and Webb may have taken it from a similar illustration of the Ionic order on II. vi. 98.

247 (Gotch 11/unnumbered)
　　Plan and elevation of one and a half bays of a Corinthian loggia.
　　Pen and ink (360×255).

This is a redrawing of Scamozzi's 'Aspetto degl Archi Corinti' (Scamozzi, II. vi. 127). Webb's greatest departure from Scamozzi's design in the niche which Webb shows without the aedicular frame. The drawing of the figure and mouse in the niche is a later addition.

248 (Gotch 11/unnumbered)
　　Plan and elevation of one and a half bays of an Ionic loggia.
　　Insc.: *15.*
　　Pen and ink (360×255).

This drawing is an almost exact copy of Scamozzi, II. vi. 91 (*see also* 246).

249C–D (Gotch 11/84) (Pl. 126)
　　Alternative sections for the Teatro Olimpico at Vicenza (on the right side of 15). With scale.
　　Insc.: verso (by Dr. George Clarke), in pencil, inked over, *The Theatre at Vicenza— designd by Palladio/describd by Inigo Jones at ye beginning of Palladio/*and (added later) *This drawing was Mr. Webbs.*
　　Pen and ink (300×390).

These two sections are copies of a design by Marc' Antonio Palladio, formerly in Jones's collection and now in RIBA BD VIII/5. Section C is a close copy of Palladio while D omits the sculpture in the attic storey. These two drawings complement in

scale and subject the antique style theatre of 16A–B. In the original sheet D was higher than C. In his drawing Webb has noted C as $43\frac{1}{2}$ feet high, and D (by summation of his dimensions) 48 feet. For the relationship between these drawings and a theatre for Somerset House, see 15.

APPENDIX

Additions and Corrections to *A Catalogue of Architectural Drawings of the 18th and 19th Centuries in the Library of Worcester College, Oxford,* by H. M. Colvin (1964)

THE opportunity has been taken to describe eight drawings that have come to light since 1964 and to correct and amplify several of the entries in the catalogue. For their help in various ways I am indebted to Mr Alan Bean, Dr T. P. Connor, Dr T. F. Friedman, and Mr John Harris.

<div align="right">H. M. C.</div>

ADDITIONAL DRAWINGS

74A. Sketch by Dr Clarke of the plan of a design for rebuilding WHITEHALL PALACE formerly attributed to Inigo Jones, but in fact by John Webb.
Ink. $8\frac{3}{4}'' \times 6\frac{3}{4}''$
Inscribed: 'The Great Court at Whitehall designed by Inigo Jones'.
This and no. 74 both represent a scheme by John Webb of which the original drawings are now at Chatsworth (Margaret Whinney, 'John Webb's Drawings for Whitehall Palace', *Walpole Society*, vol. xxxi, 1946, pl. xxiv).

491A. Plan of WORCESTER COLLEGE Chapel corresponding to the designs made by James Wyatt in 1783 and evidently from Wyatt's office.
Ink. *Scale*: 1 *in.* = 4 *ft.* 13″ × 19″

491B. Plan and elevation by James Pears of a proposed screen-wall on the west side of the Quadrangle of WORCESTER COLLEGE.
Ink and wash. *Scale*: 1 *in.* = 6 *ft.* 6 *in.* $12\frac{3}{4}'' \times 20\frac{1}{2}''$
Endorsed: 'Pears Drawings'.
James Pears was Oxford master-builder much employed by James Wyatt. The existing screen-wall does not follow this design.

492A. Estimate for new sash windows and frames for the west side of the Library of WORCESTER COLLEGE, with drawings, submitted by John Hudson, March 1806.
John Hudson was an Oxford carpenter and surveyor.

492B. Estimate for works at WORCESTER COLLEGE, with elevation of a doorway and design for layout of garden area between the west end of the south range and the east end of the lake, submitted by John Hudson, 18 Jan. 1817.
Ink and wash. *2 foolscap sheets*

492C. Plan and elevation by John Hudson for the Gothic gateway on the south side of the Provost's Garden at WORCESTER COLLEGE, *c.* 1817.
Ink and wash. *Scale:* $\frac{1}{2}$ *in.* = 1 *ft.* $12\frac{3}{4}'' \times 8''$
The existing gateway corresponds to this design.

520. Elevation of a small pedimented building with Ionic pilasters, by Dr Clarke.
Ink and wash. *Scale:* 1 *in.* = 5 *ft.* $9\frac{1}{2}'' \times 14\frac{1}{2}''$

521. Sketch of the elevation of one bay of a three-storied building, by Dr Clarke.
Pencil. $6\frac{1}{4}'' \times 7\frac{3}{4}''$

CORRECTIONS AND ADDITIONAL NOTES

12, 39. These two plans are probably in the hand of Henry Aldrich, Dean of Christ Church (1648–1710). This is established by comparing them with the original drawings for the plates of Aldrich's *Elementa Architecturae Civilis* (see Catalogue No. 519). The fact that the drawings for these plates were from Aldrich's own hand is clear from a MS. note by Dr Clarke on the flyleaf of an incomplete proof copy of the book (shelfmark BN. 9) bound to match the volume of drawings: *55 Tabulae, a Decano delineatae, quae in hisce Tabulis, respondeant.*
The annotations on No. 39 are by John Talman.

30, 31. These two perspective drawings are also probably by Henry Aldrich. But No. 14, which shows an identical North Building, is undoubtedly in John James's meticulous hand, and must presumably be regarded as a fair copy of Aldrich's design.

47. In line 4, for 'when' read 'to be'

71, 72, 75. 'Mr Berkeley' can probably be identified with John Symes Berkeley (d. 1736) of Stoke Gifford, Glos. (near Bristol), whose grounds included a terrace commanding an extensive view (see Kip, *Britannia Illustrata*, ii, 1716, pl. 47). On this terrace there still stands an early 18th-century garden building similar in size, though not in design, to the one contemplated in these drawings.

77. For '1726–8', read '*c.* 1717–20'

79. This elevation is a good example of Dr Clarke's Palladian tendencies, as it is based on John Webb's design for the Duke of Lennox's house at Cobham in Kent, dated 1648, in Dr Clarke's collection.

98–105. These drawings are connected with the two brass candlesticks which Dr Clarke presented to the church of St. Peter in the East, Oxford (J. Ingram, *Memorials of Oxford*, iii, 1837, p. 11, note *p*).

123. For '*c*.1709' read '1733–6'

173–6. These designs for a single-storey lodge resemble in plan and dimensions but not in elevation the two-storied lodge which Lord Lexington built at Averham Park, Notts., in about 1720 (M. W. Barley and N. Summers, 'Averham Park Lodge' in *Transactions of the Thoroton Society*, vol. 65, 1961, pp. 47–56). Lord Lexington also possessed a lodge near Windsor in which he entertained William III in 1693 (*Calendar of State Papers Domestic, 1698*, p. 142).

177–180, 182–3. Lord Harcourt (?1661–1727) acquired Cokethorpe in 1709, but these drawings must be subsequent to his advancement to the peerage in Sept. 1711. They appear to relate to the south (not 'west') wing, though none of the plans corresponds exactly to what was built, and there were further extensive alterations later in the 18th century and in 1913. In November 1712 it was reported that Lord Harcourt had 'laid out within two years £4000 at Cockrop' (Hist. MSS. Comm., *Portland*, vii, p. 115).

181. This sketch-plan of a town-house dated April 1720 must represent a scheme (presumably by Dr Clarke himself) for Harcourt House, Cavendish Square, London. The width of the frontage (72 ft.) corresponds to the known width of Lord Harcourt's site, upon which he shortly afterwards erected a house designed by Thomas Archer.

190. Comparison with the plan of Maiden Bradley engraved in C. Campbell, *Vitruvius Britannicus*, ii (1717), pl. 56, shows that the latter has been printed in reverse. Only the west wing now survives, not the recessed centre as stated in N. Pevsner, *Wiltshire* (1975), p. 320.

192. The house represented in this sketch does not correspond to views of Ranelagh House, Chelsea, as built by Lord Ranelagh *c*.1688–9 (C. G. T. Dean, *The Royal Hospital Chelsea* (1950), p. 144). It may therefore be a scheme for another house for Lord Ranelagh, who died in 1712.

241. A design by Dr Clarke for enlarging Cokethorp Park, Oxon., for Lord Harcourt (cf. No. 178).

247. Perhaps a design for the Master's House at University College, Oxford.

248. Probably designs for the Master's House at University College, Oxford.

257–8. Designs for the Master's House at University College, Oxford.

286. A copy of one of William Talman's plans for the Hampton Court Trianon which he designed for King William III (cf. *Journal of the Warburg & Courtauld Institutes* xviii, 1955, pl. 34c).

290. A design for the Master's House at University College, Oxford.

292. Probably related to the designs for Lord Lexington's Lodge at Averham Park, Notts. (cf. Additional Notes on Nos. 173–6).

295. A design for the Master's House at University College, Oxford.

303. A design for Harcourt House, Cavendish Square, London (cf. Additional Notes on No. 181).

318–20. These three designs relate not to Eastbury, Dorset, but to Sir William Wyndham's house at Witham, Somerset. The pedimented portico built *c.*1717 and illustrated by Colen Campbell, *Vitruvius Britannicus*, ii (1717), pls. 91–2, appears to have been initiated by William Talman, but James Gibbs was also concerned (John Harris, 'The Transparent Portico', *Architectural Review*, Feb. 1958, pp. 108–9).

321. These drawings are duplicates of the ones drawn by Hawksmoor and engraved by Burghers for publication in the 1714 edition of Henry Maundrell's *Journey from Aleppo to Jerusalem*.

417–20. These four plans are probably designs for Harcourt House, Cavendish Square, London (cf. No. 181).

421. A design by Dr Clarke for enlarging Cokethorpe Park, Oxon., for Lord Harcourt (cf. No. 178).

492. This drawing is based on the view of Worcester College in the *Oxford Almanack* of 1804, with the addition of the screen-wall, etc.

Plate 49 For 'John James' read 'Henry Aldrich'
Plate 96 For '*c.*1709' read '1733–6'
Plate 117 For 'Robert Blechynden' read 'Richard Blechynden'
Plate 126 For 'Ranelagh House, Chelsea' read 'a house for Lord Ranelagh'

PLATES

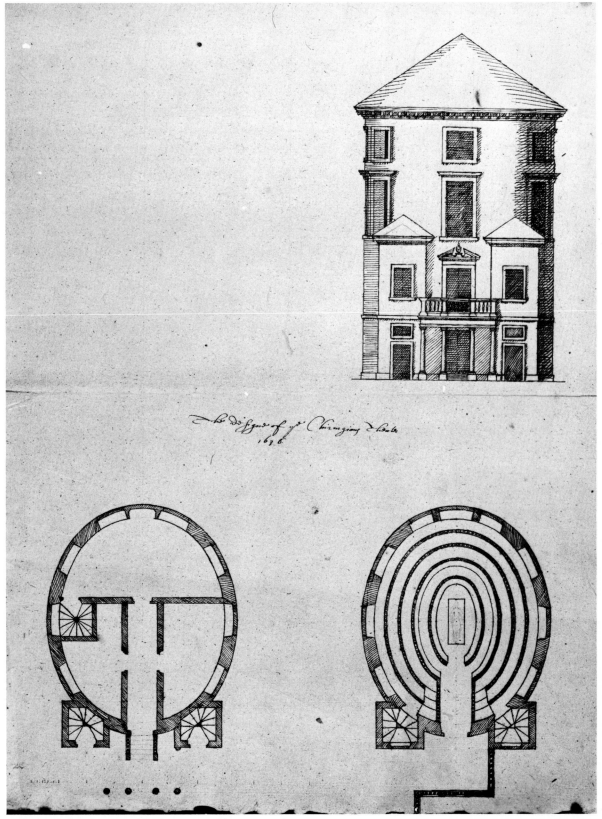

1 Plans and elevation for the Barber Surgeon's Anatomy Theatre

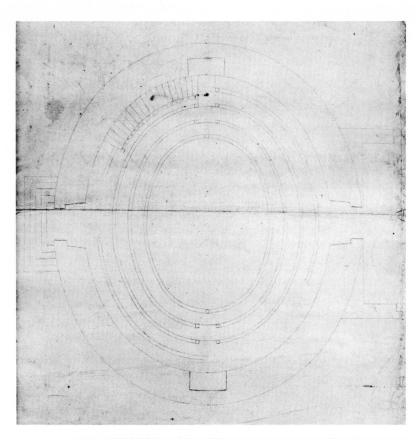

2 Preliminary design
showing arrangement
of seating in the Barber
Surgeon's Anatomy
Theatre

3 Preliminary design
giving a section through
the seating in the
Barber Surgeon's
Anatomy Theatre

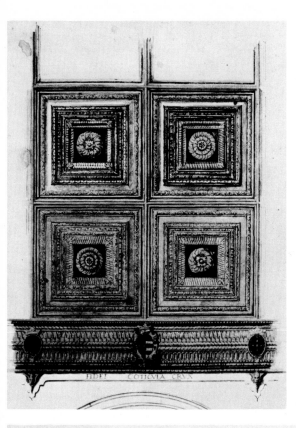

4 Ceiling design for the
Marquess of Bucking-
ham's Second Lodging
in Whitehall

5 Plans and stage
elevation of the Cock-
pit Theatre, Whitehall

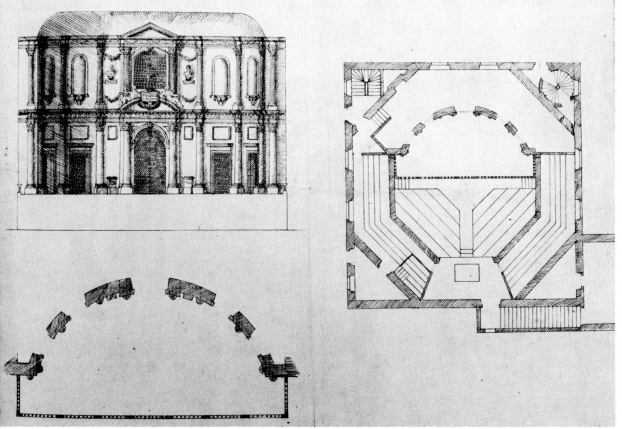

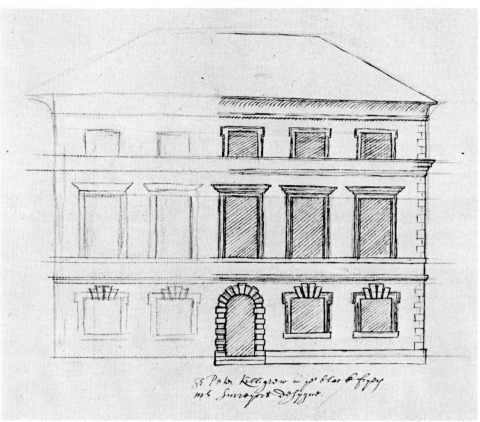

6 Elevation of Sir Peter Killigrew's House in Blackfriars

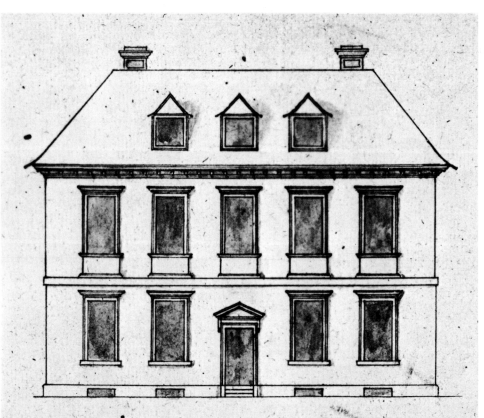

7 Elevation of a house in Lord Maltravers's development in Lothbury, London

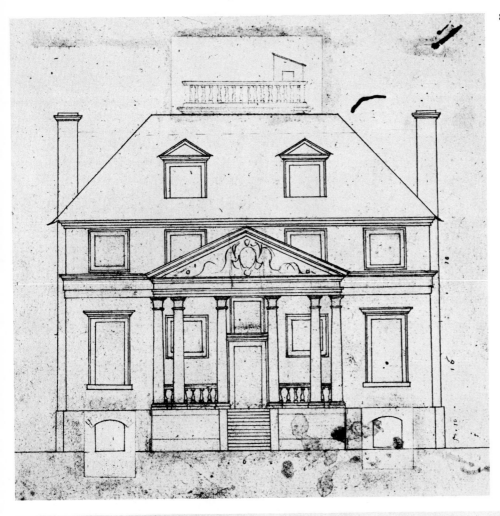

8 Elevation of a house
with a hexastyle
portico in Lord Mal-
travers's development
in Lothbury, London

9 Terrace elevation in
Lord Maltravers's
development in Loth-
bury, London

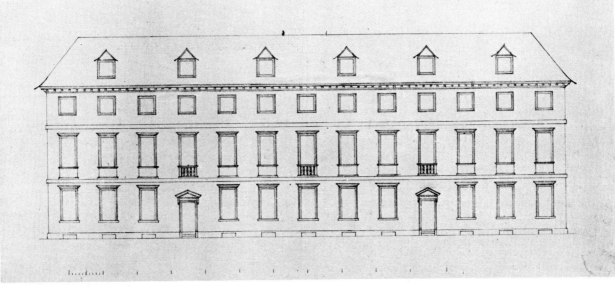

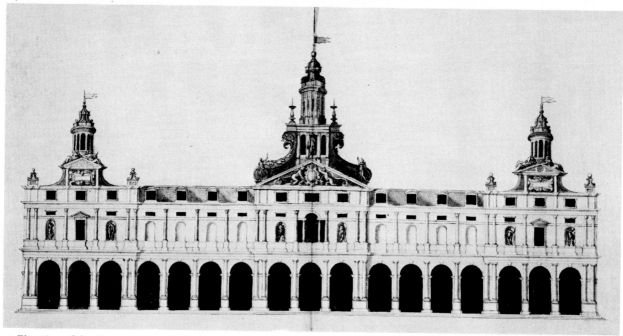

10 Elevation of the New Exchange in the Strand by Inigo Jones

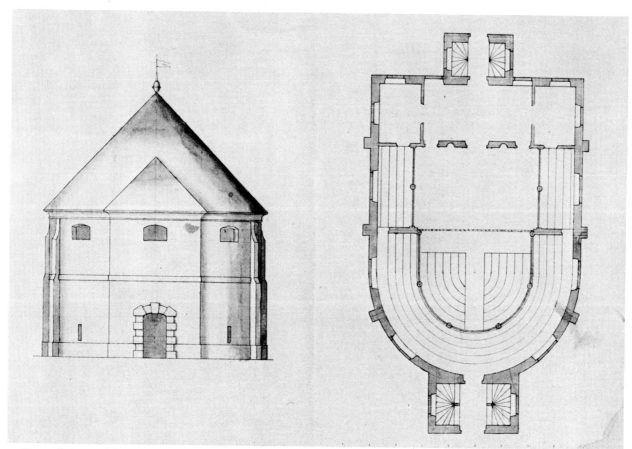

11 Plan and elevation for the Phoenix Theatre in Drury Lane

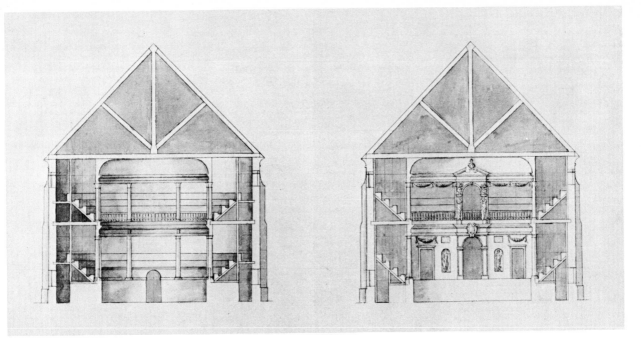

12 Transverse sections through the Phoenix Theatre in Drury Lane

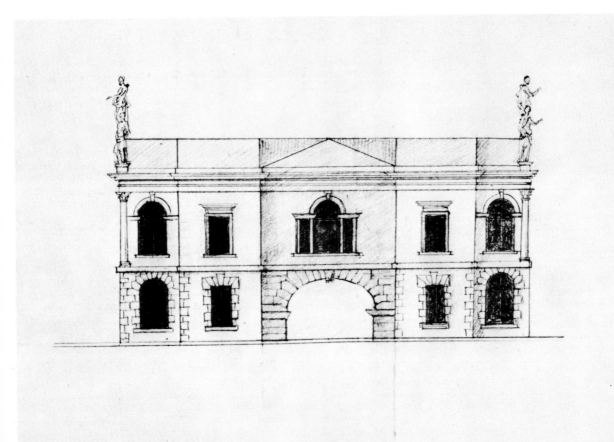

13 Side elevation of the Queen's House at Greenwich

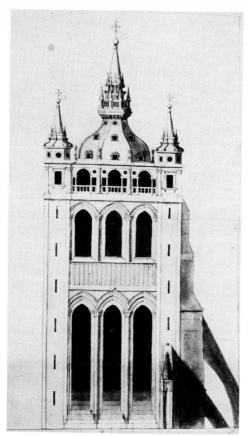

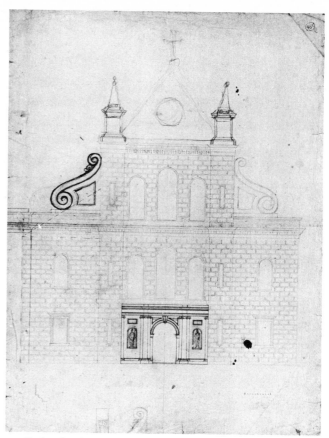

14 Design for the completion of the central tower of Old St. Paul's Cathedral

15 Design for the north transept of Old St. Paul's Cathedral

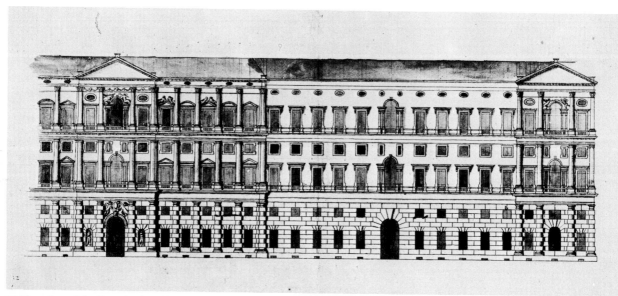

16 Elevation of the Strand wing of Somerset House, London: first design

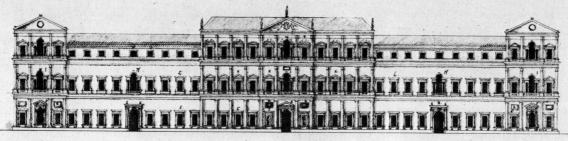

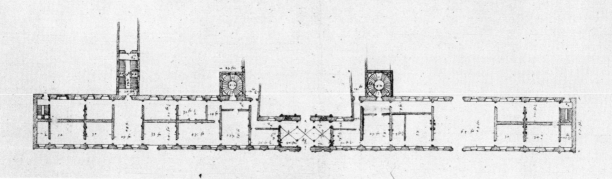

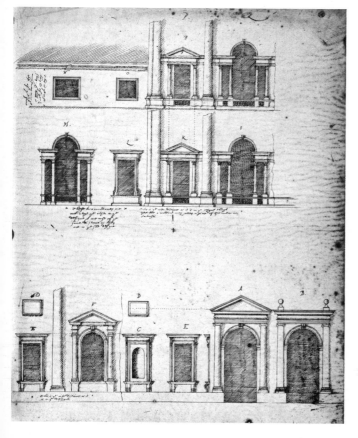

17 Plan and elevation of the Strand wing of Somerset House, London: second design

18 Window from the second design of the Strand wing of Somerset House, London

19 Half-plan for the
ground-floor of the
Star Chamber,
Westminster

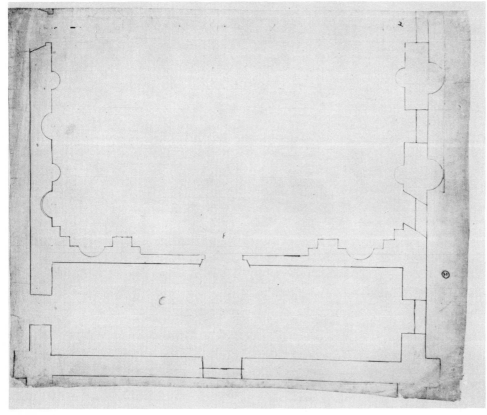

20 Half-plan for the
ground-floor entrance
to the Star Chamber,
Westminster

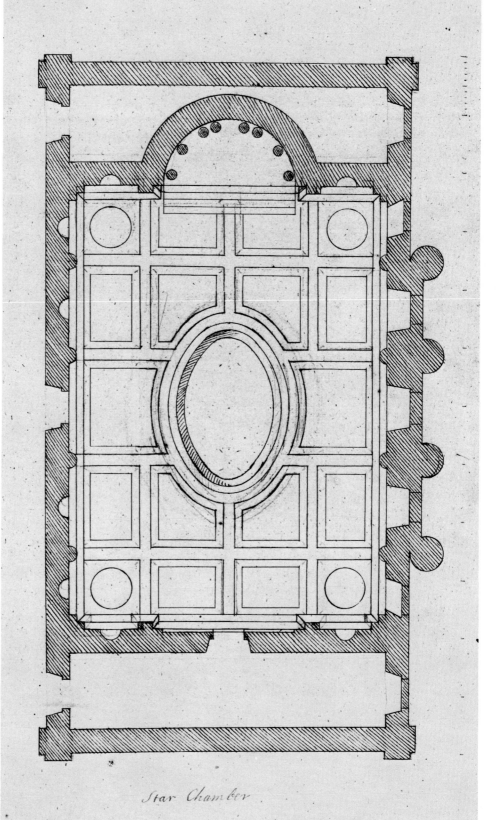

Star Chamber

21 Plan of the ceiling for
the Star Chamber,
Westminster

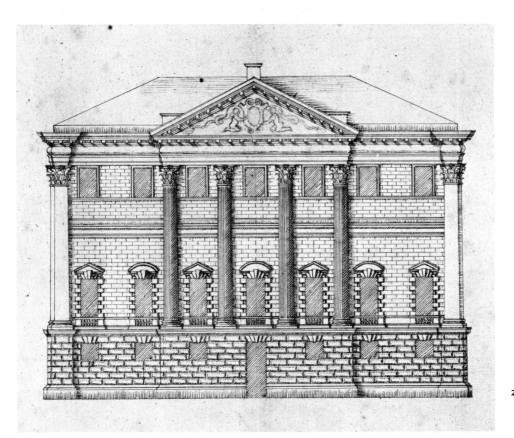

22 Elevation of the portico front of the Star Chamber, Westminster

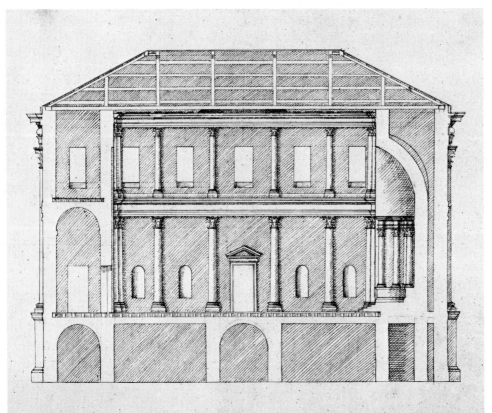

23 Longitudinal section through the Star Chamber, Westminster

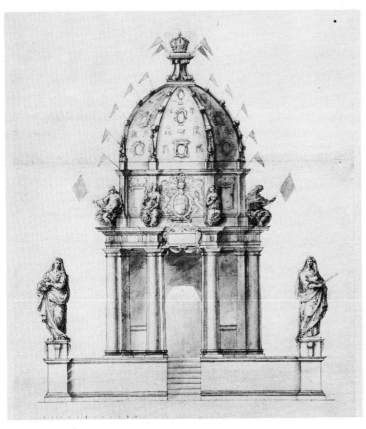

24 Design for the
catafalque for James I
at Westminster Abbey

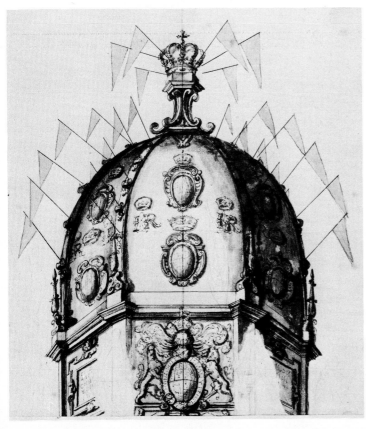

25 Design for the dome
of the catafalque for
James I at
Westminster Abbey

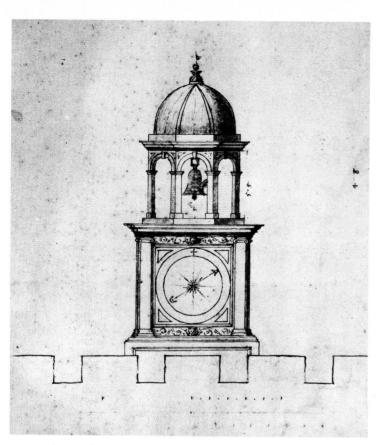

26 Design for a Clock Turret at Whitehall Palace

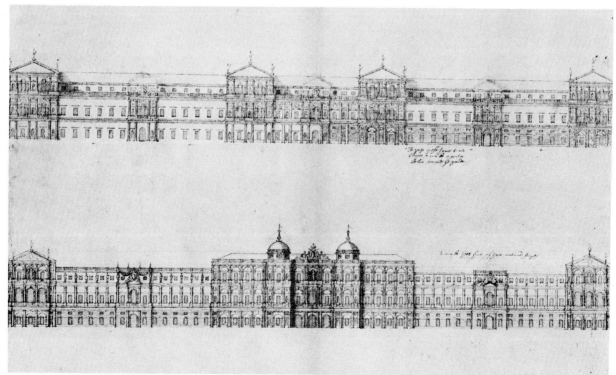

27 Elevation for the river and park fronts of Whitehall Palace

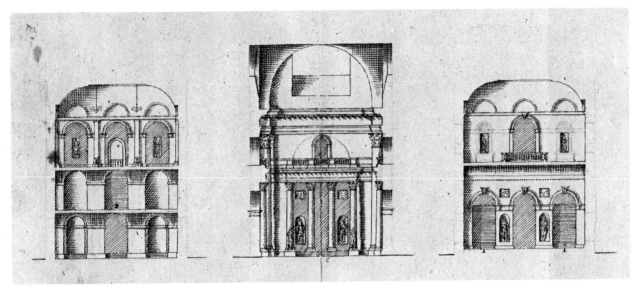

28 Three sections of the Staircase Hall at Whitehall Palace

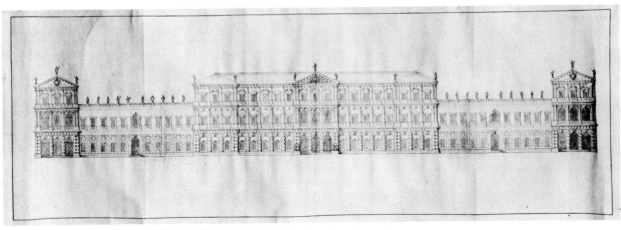

29 Elevation of a short front of Whitehall Palace

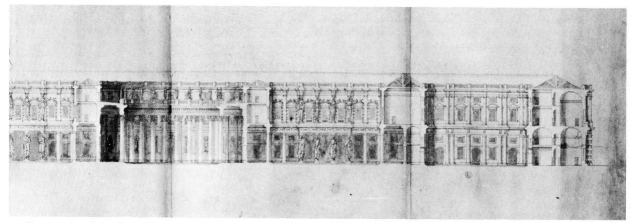

30 Cross-section through inner courts at Whitehall Palace

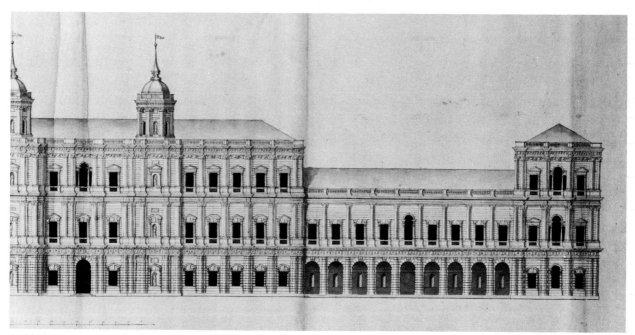

31 Elevation for a short front of Whitehall Palace

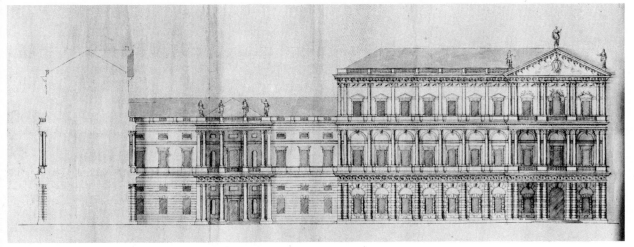

32 Half-elevation of the Great Court of Whitehall Palace

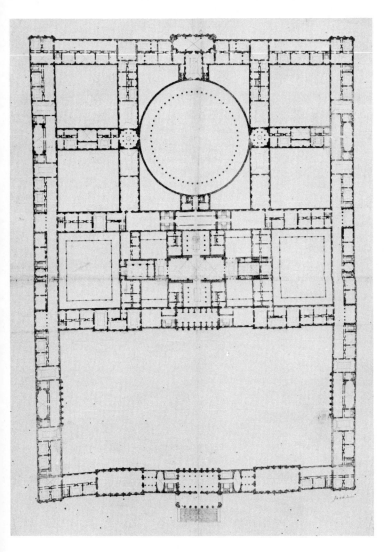

33 Plan of the ground
floor of Whitehall
Palace

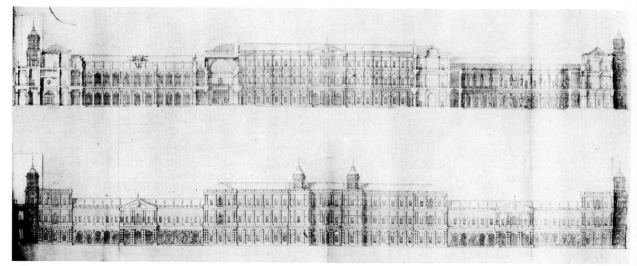

34 Section and elevation through the Court at Whitehall Palace

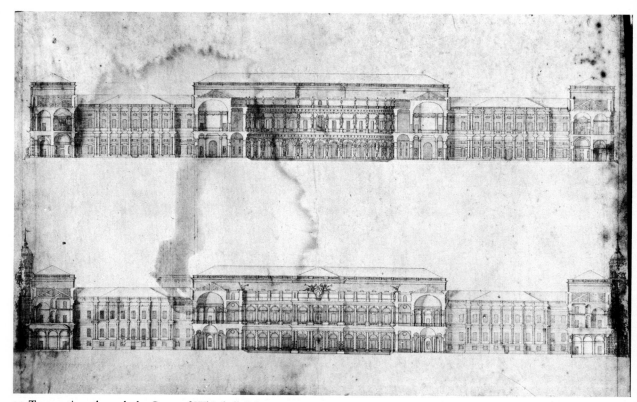

35 Two sections through the Court of Whitehall Palace

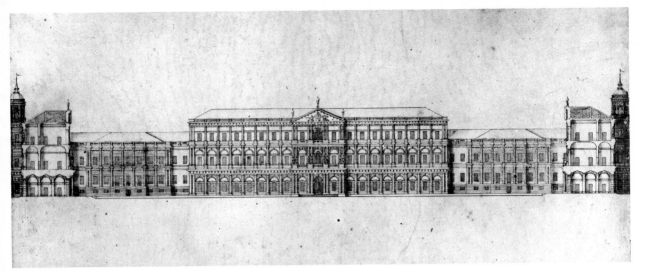

36 Section through the Court of Whitehall Palace

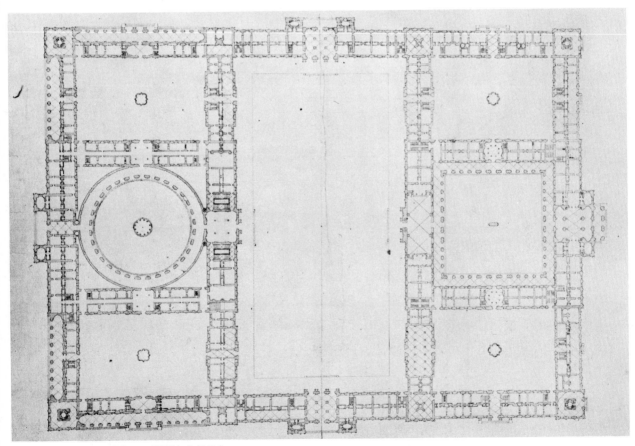

37 Plan of the ground floor of Whitehall Palace

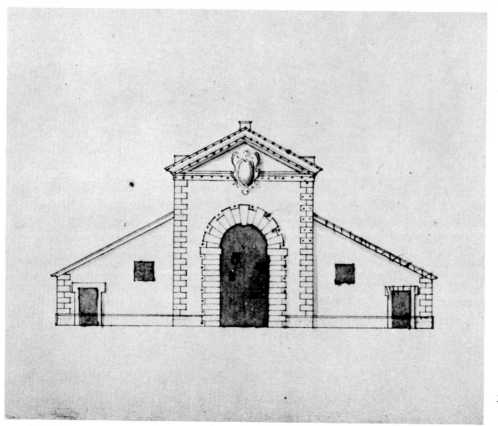

38 Elevation for a stable,
possibly for New-
market Palace

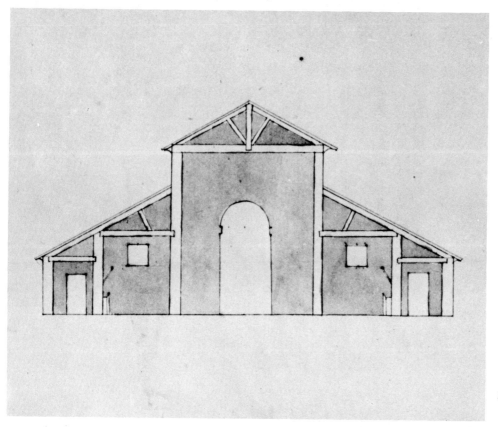

39 Section through a
stable, possibly for
Newmarket Palace

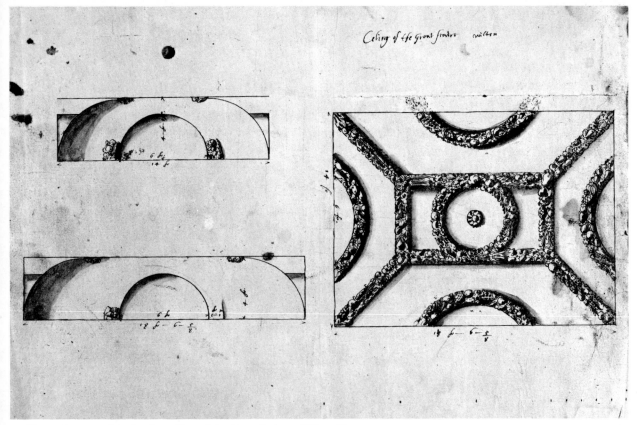

40 Plan and two sections for the ceiling of the Great Stairs at Wilton House

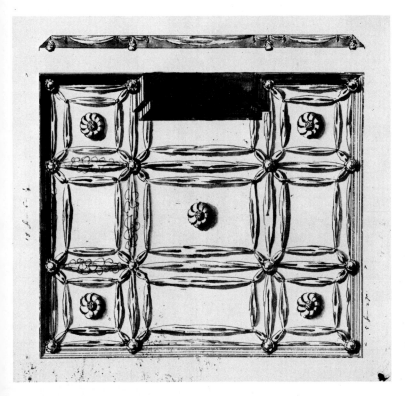

41 Plan and section of
the ceiling for the
Cabinet Room at
Wilton House

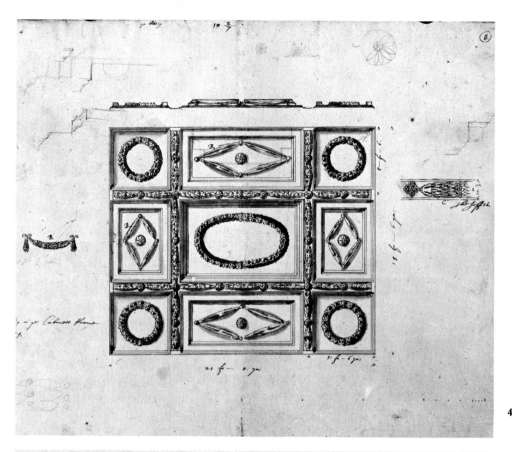

42 Plan of the ceiling for the Cabinet Room, Wilton House

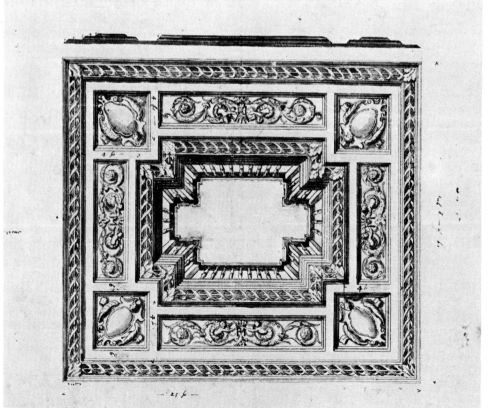

43 Plan of the ceiling for the Passage Room, Wilton House

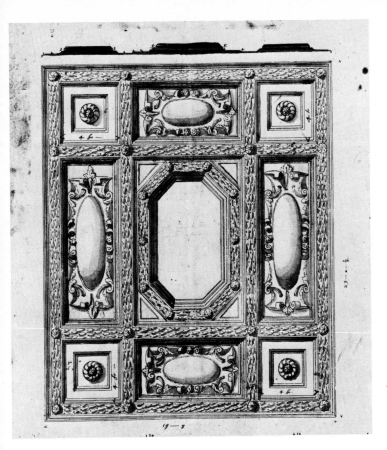

44 Plan and section of the
ceiling for the Coun-
tess of Pembroke's
Bedchamber at
Wilton House

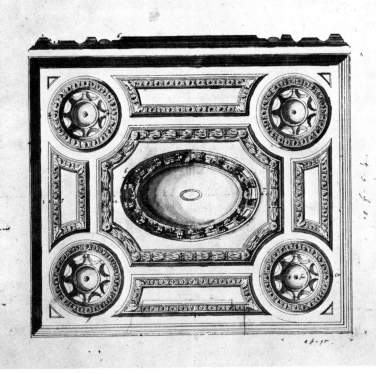

45 Plan and section of the
ceiling for the Coun-
tess of Caernarvon's
Withdrawing Room
at Wilton House

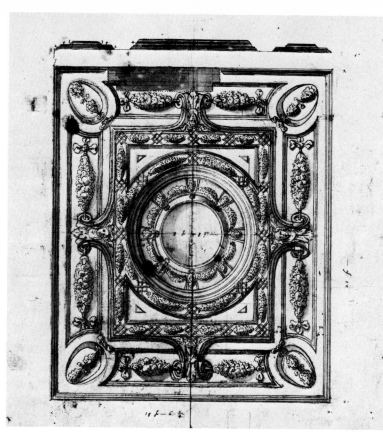

46 Plan and section of the ceiling for the Countess of Caernarvon's Bedchamber at Wilton House

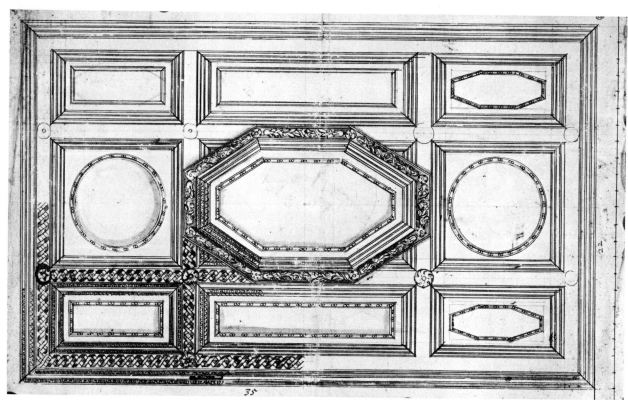

47 Ceiling design of nine compartments for Wilton House

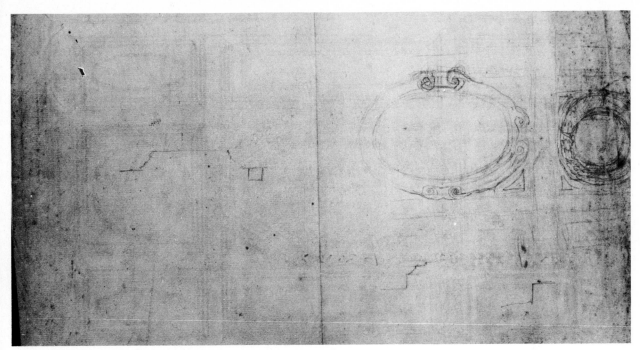

48 Sketch designs for a ceiling with nine compartments for Wilton House

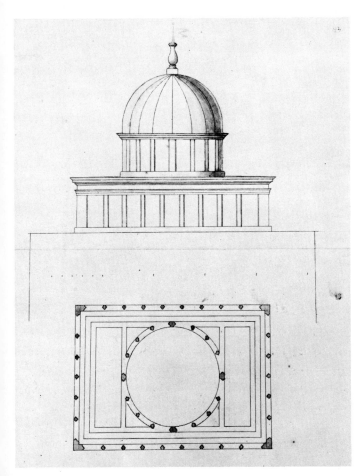

49 Plan and elevation for a tempietto raised on a base

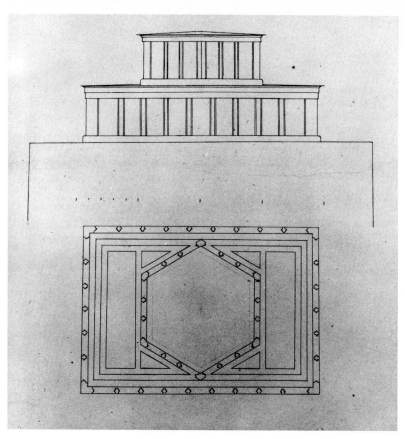

50 Plan and elevation for a tempietto raised on a base

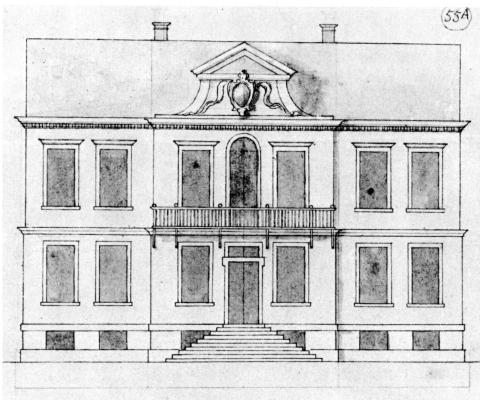

51 Elevation of a seven-bay house

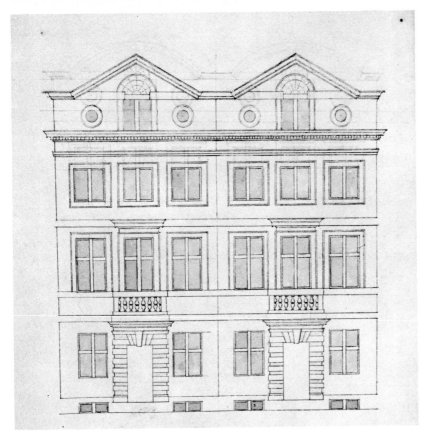

52 Elevation of a pair of three-bay houses

53 Elevation for a three-bay town house with Palladian window

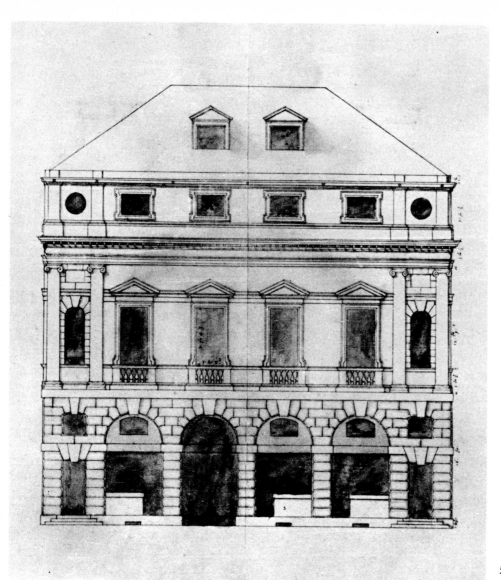

54 Elevation of a design
for a group of shops

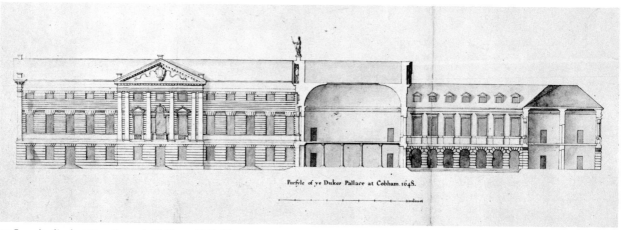

Parfyle of ye Dukes Pallace at Cobham 1648.

55 Longitudinal section through Cobham Hall, Kent

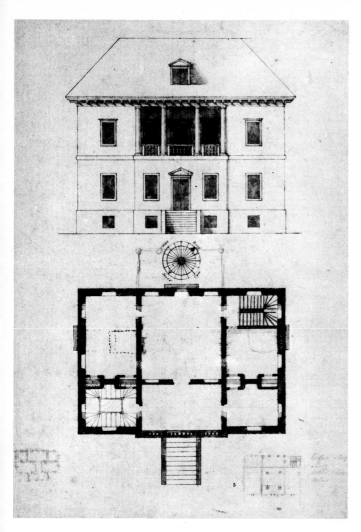

56 Elevation and plan for
a small hunting-lodge
or house at Hale Park,
Hants

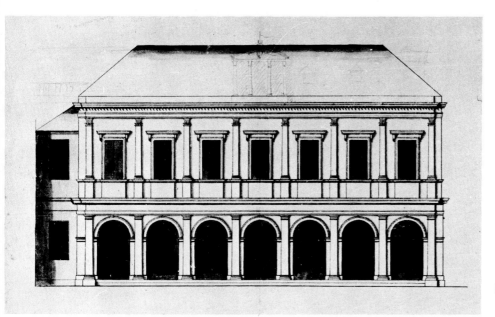

57 Elevation for the
College of Physicians,
London

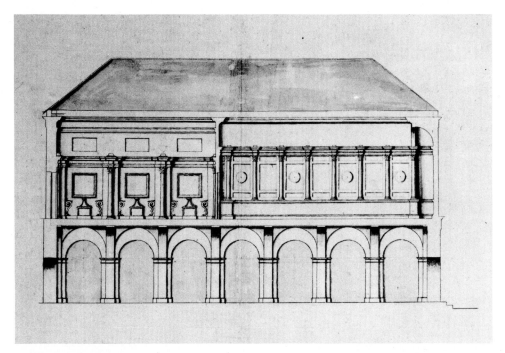

58 Longitudinal section
through the Library of
the College of
Physicians, London

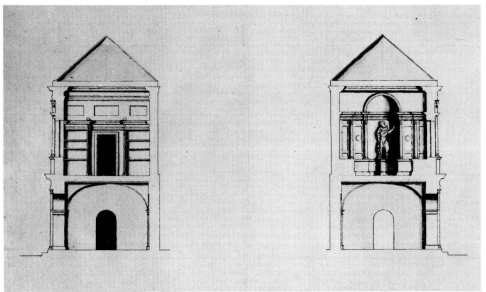

59 Transverse sections
through the Library of
the College of
Physicians, London

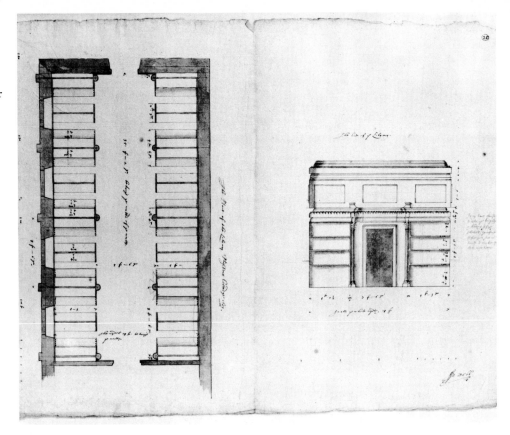

60 Elevation and plan for
the Library of the
College of Physicians,
London

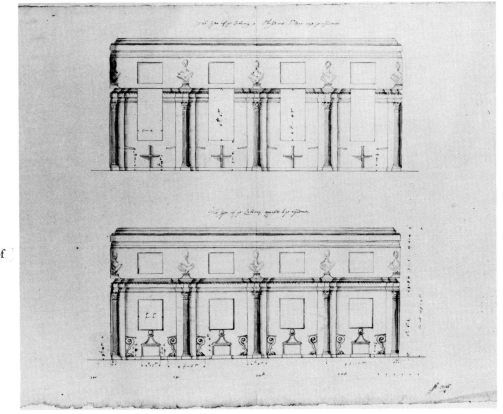

61 Longitudinal section
through the Library of
the College of
Physicians, London

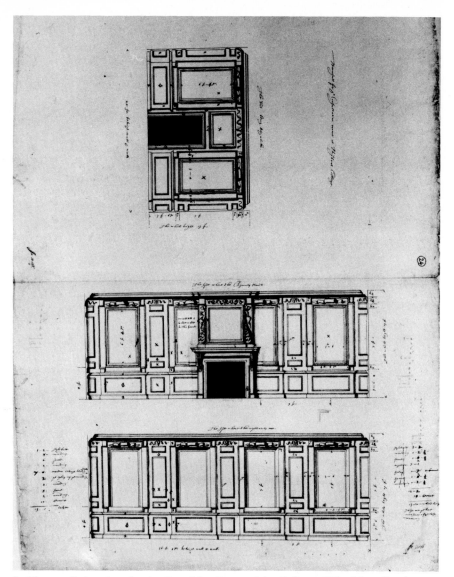

62 Three wall elevations for the Consulting Room of the College of Physicians, London

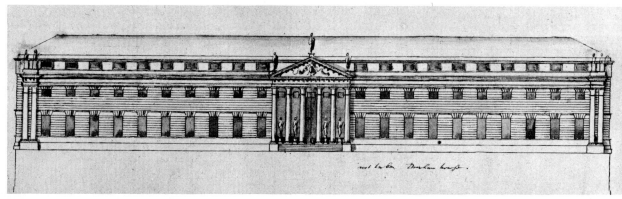

63 Elevation of the Strand front of Durham House, London

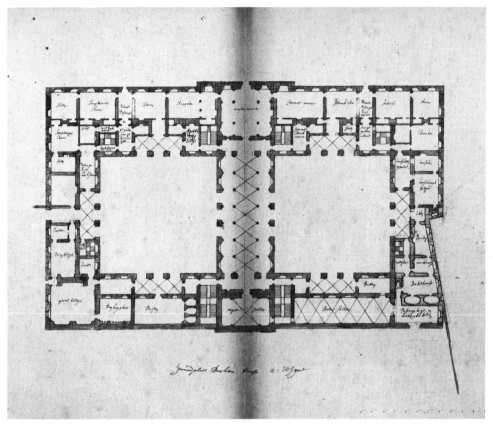

64 Plan of the ground floor of Durham House, London

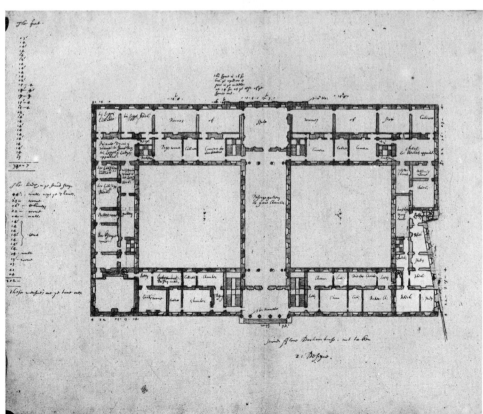

65 Plan of the principal floor of Durham House, London

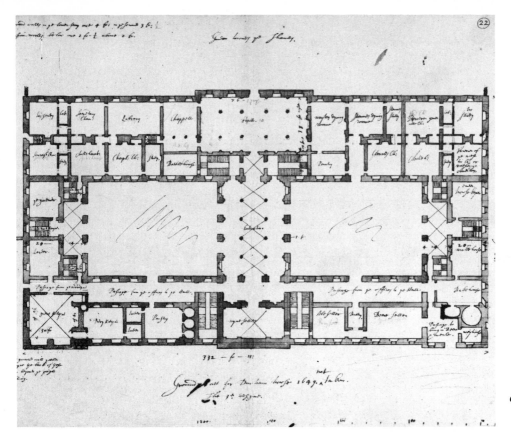

66 Plan of the ground floor of Durham House, London

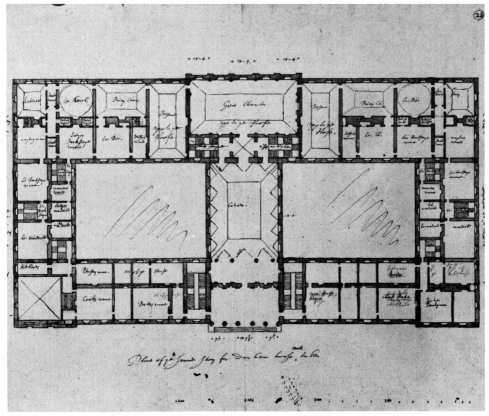

67 Plan of the principal floor of Durham House, London

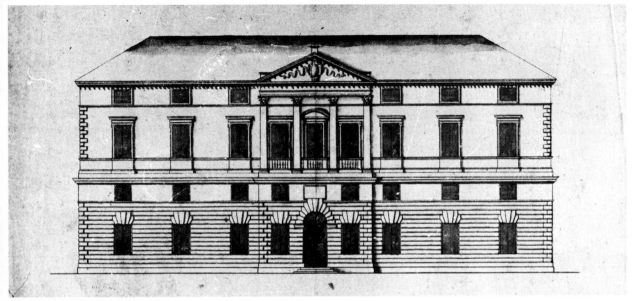

68 Elevation of a smaller design for Durham House, London

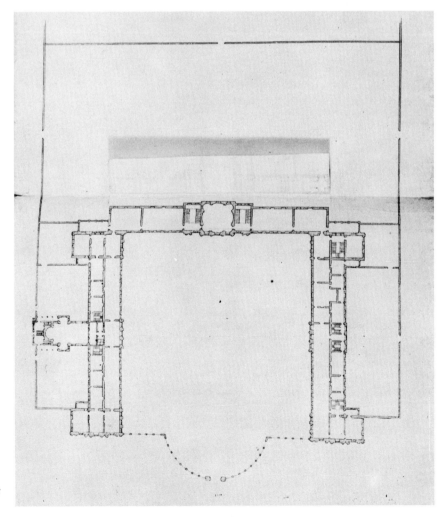

69 Preliminary plan for
Greenwich Palace

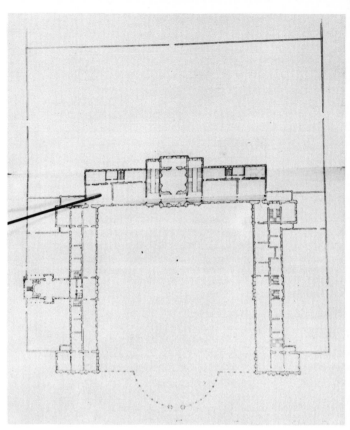

70 Variant plan for
Greenwich Palace

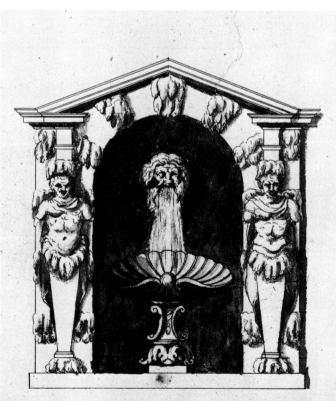

71 Design for a fountain
at Greenwich Palace

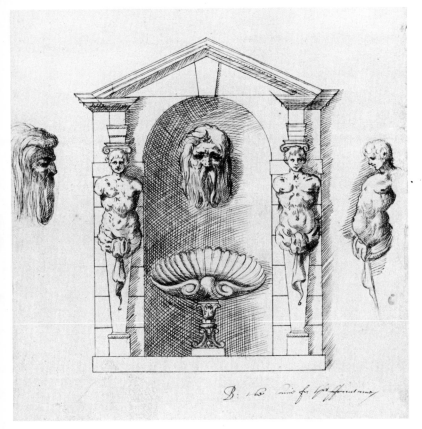

72 Design for a fountain
at Greenwich Palace

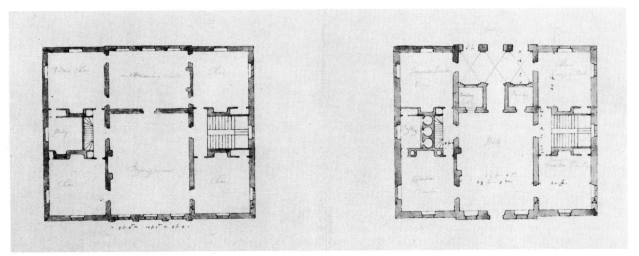

73 Design for the ground and principal floor of a house at Maiden Bradley, Wilts.

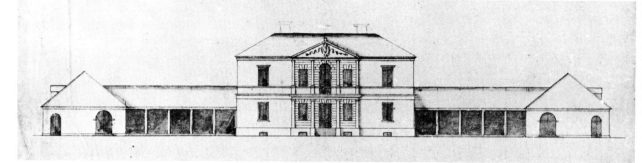

74 Elevation of a design for a five-bay villa with wings

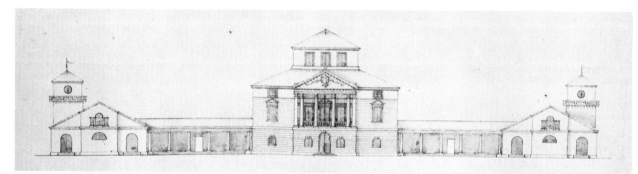

75 Elevation of a design for a five-bay villa with wings and towers

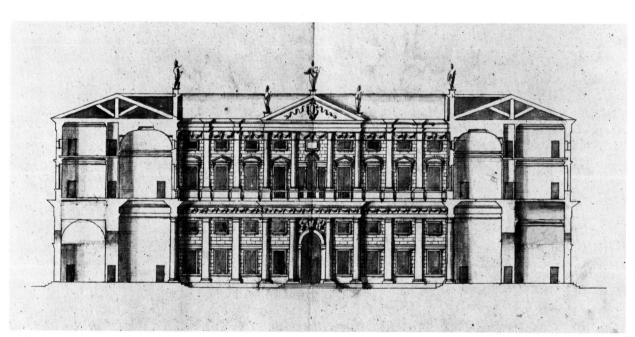

76 Courtyard elevation of a design for a country house or palace

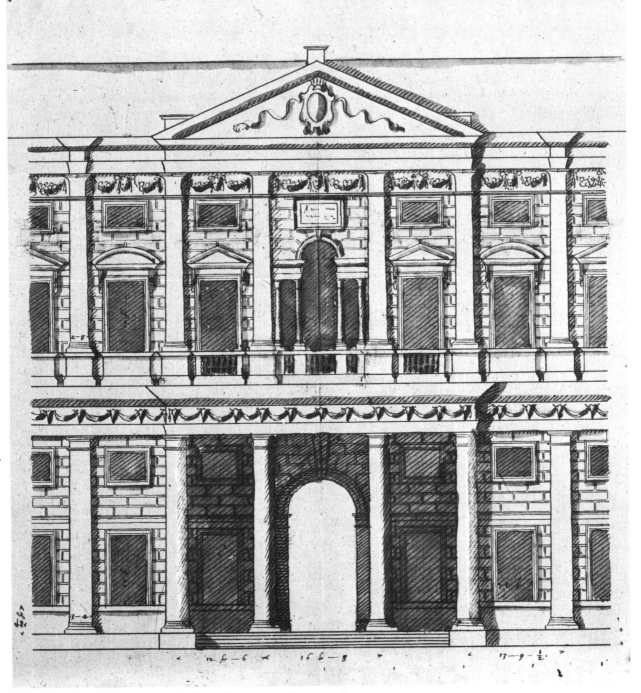

77 Centre of courtyard elevation of a design for a country house or palace

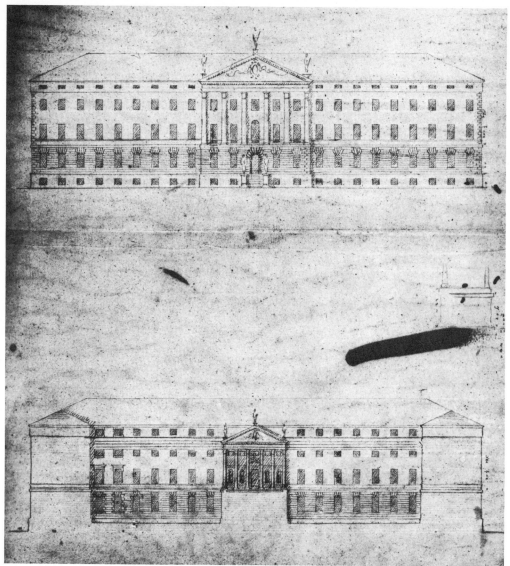

78 Elevation and section through a large country house or palace

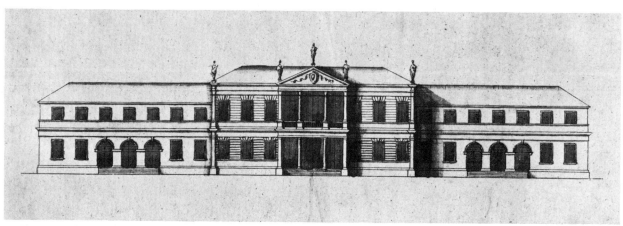

79 Elevation of a design for a nine-bay country house with wings

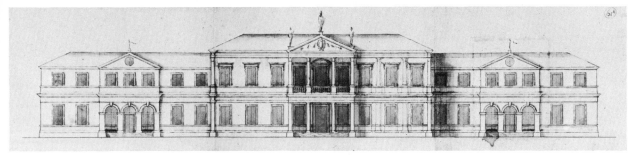

80 Variant elevation of a design for a nine-bay country house with wings

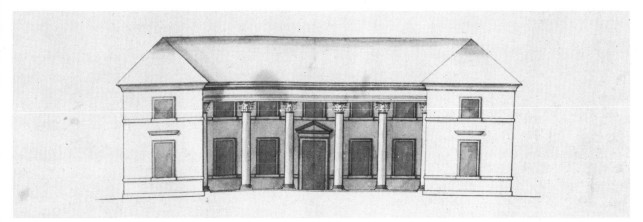

81 Elevation of a design for a five-bay country house

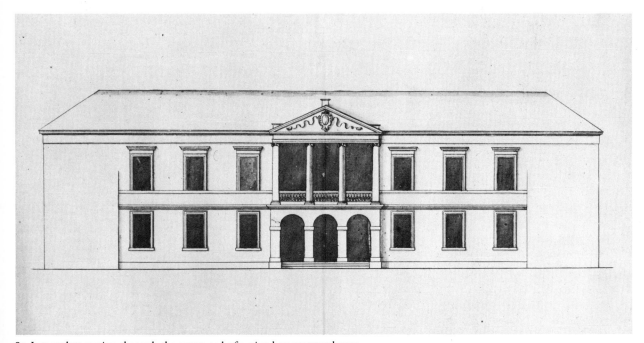

82 Incomplete section through the courtyard of a nine-bay country house

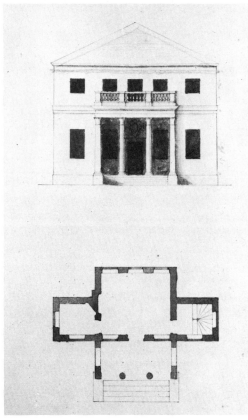

83 Elevation of a design for a porticoed lodge

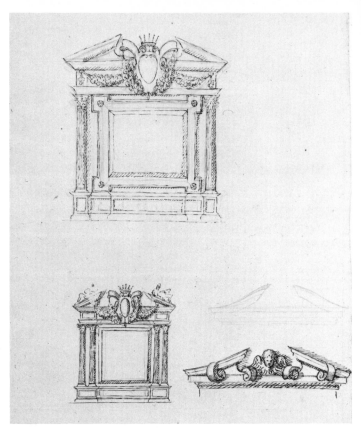

84 Four drawings for an overmantle

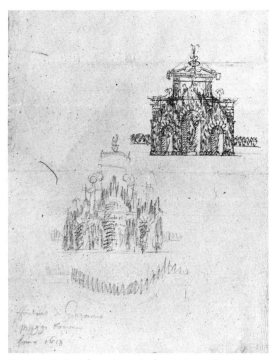

85 Two designs for a fountain from Maggi, *Fontane Diverse . . . di Roma*, 1618

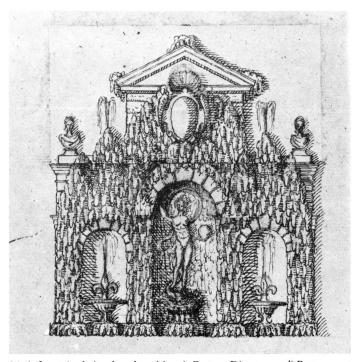

86 A fountain design based on Maggi, *Fontane Diverse . . . di Roma*, 1618

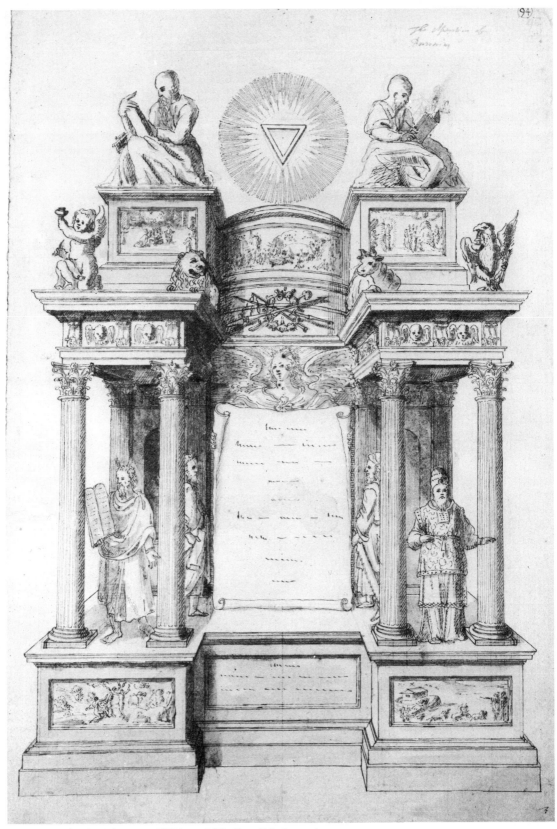

87 Drawing for the title-page of Walton, *Biblia Sacra Polyglotta*, 1657

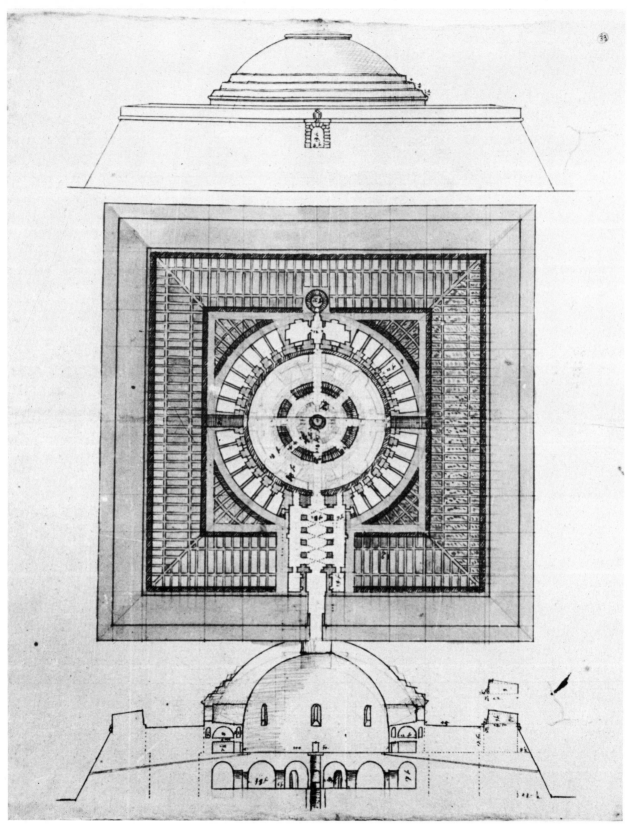

88 Plan, elevation, and section of a design for a mausoleum

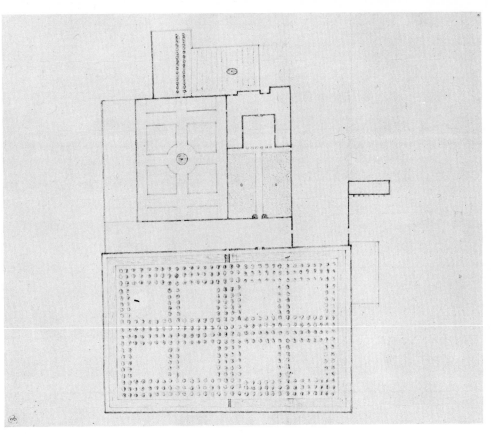

89 Plan of the house and gardens at Waltham Abbey, Essex

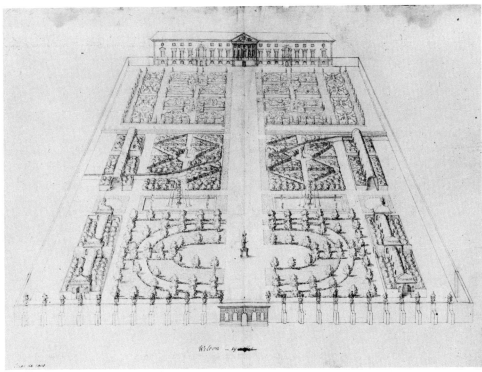

90 View of the south front and garden at Wilton House, Wilts.

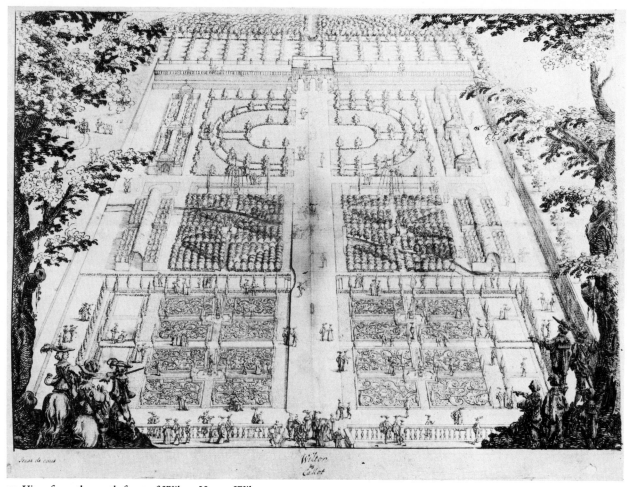

91 View from the south front of Wilton House, Wilts.

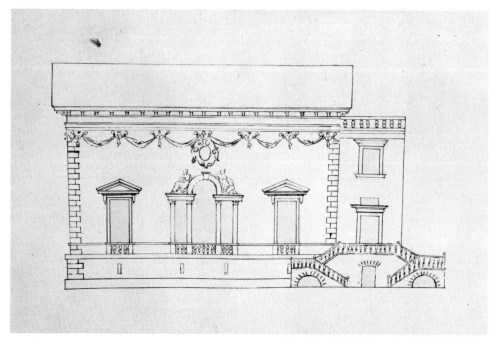

92 Side elevation for the proposed chapel at Wilton House, Wilts.

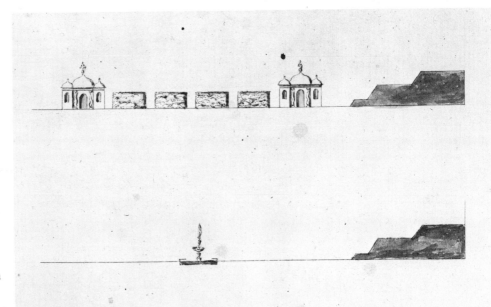

93 Two sections through
the elevated terrace
and lower garden at
Wilton House, Wilts.

94 Unfinished design for the inner wall of a grotto at Wilton House, Wilts.

95 Study for two panels for a grotto at Wilton House, Wilts.

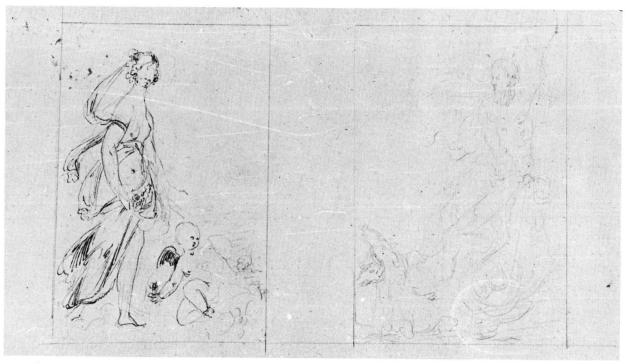

96 Unfinished study for two panels for a grotto at Wilton House, Wilts.

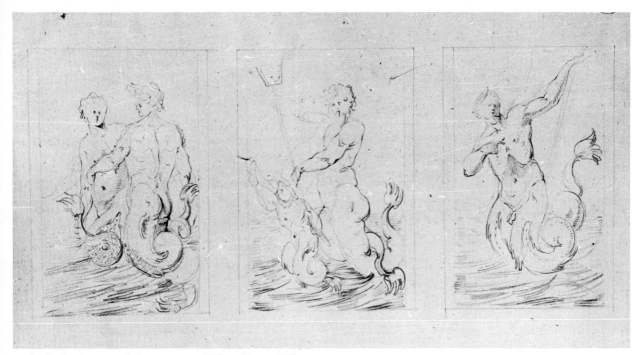

97 Study for three panels for a grotto at Wilton House, Wilts.

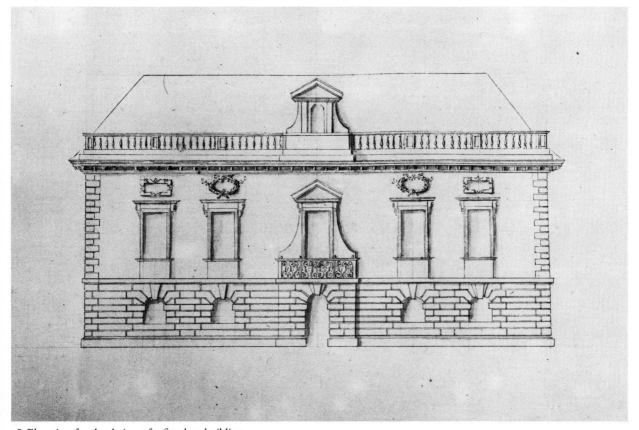

98 Elevation for the design of a five-bay building

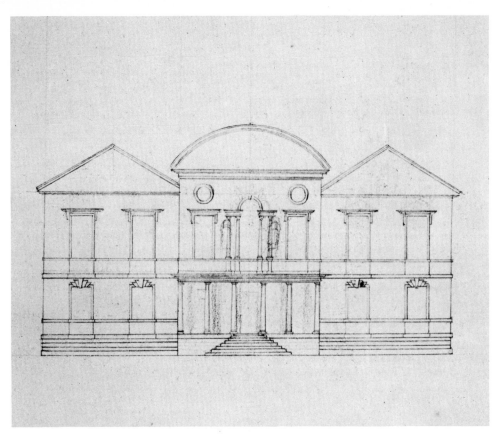

99 Elevation for a design of a seven-bay house

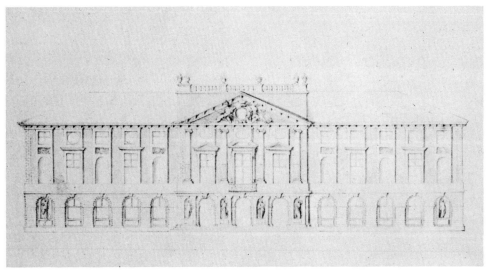

100 Elevation for the design of a French-style country house of thirteen bays

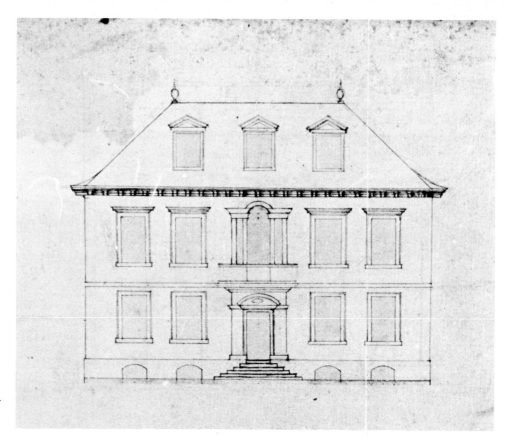

101 Elevation for the
design of a five-bay
house with hipped
roof

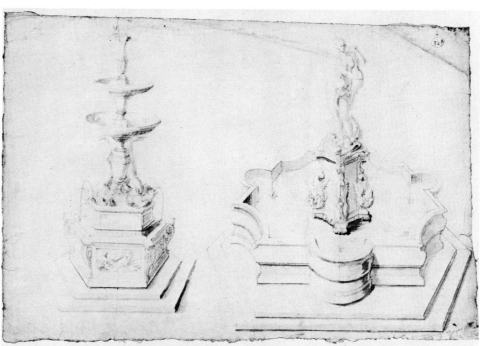

102 Two designs for a
pedestal fountain

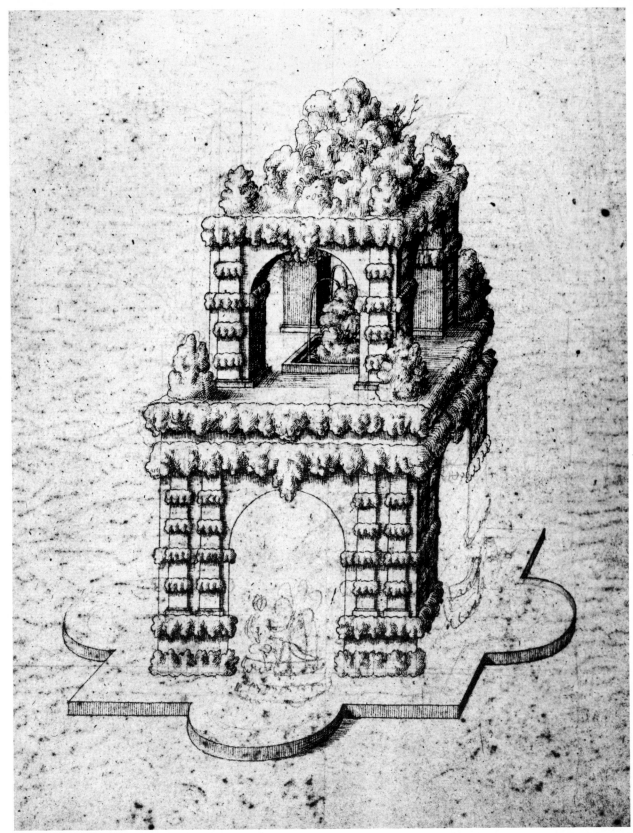

103 Design for a two-storeyed fountain with frosted rustication

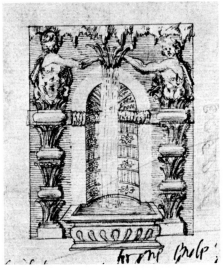

104 Design for a wall
fountain

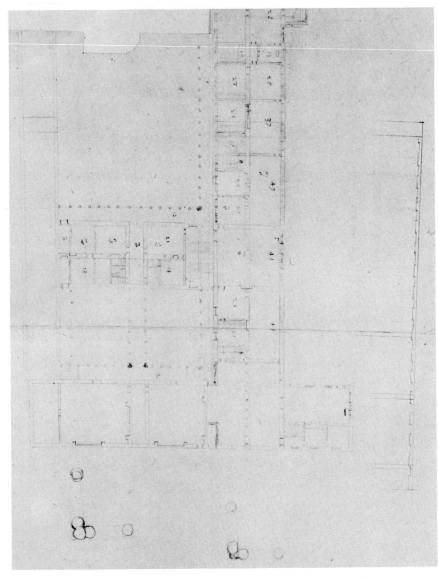

105 Unfinished survey
plan of a large
country house

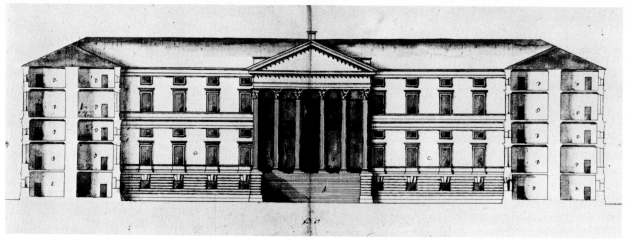

106 Elevation of the courtyard front of a large country house with portico

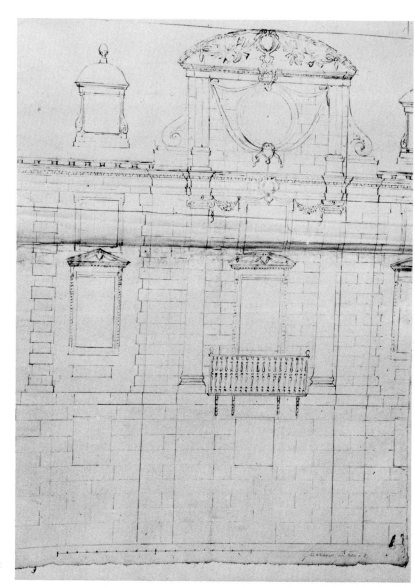

107 Part elevation of a
design for a palace at
Whitehall

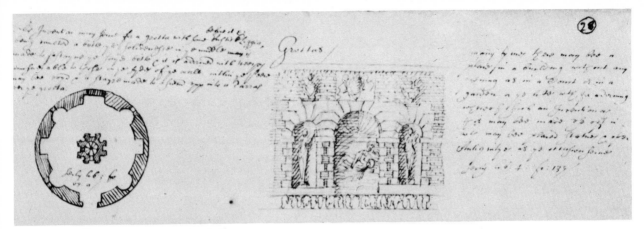

108 Plan and elevation for a grotto after Serlio

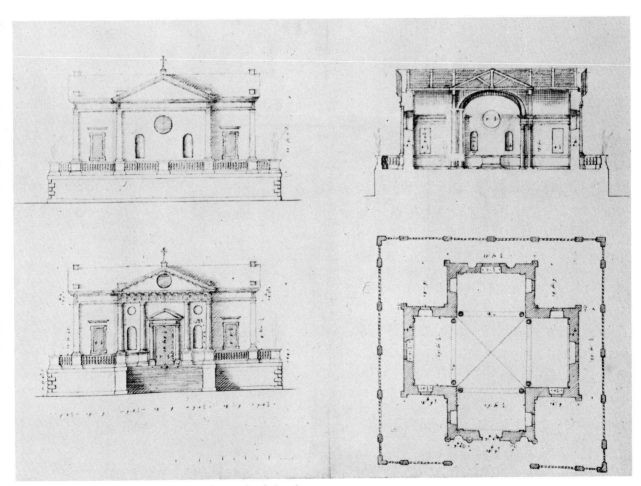

109 Plan, elevations, and section of a small centralized church

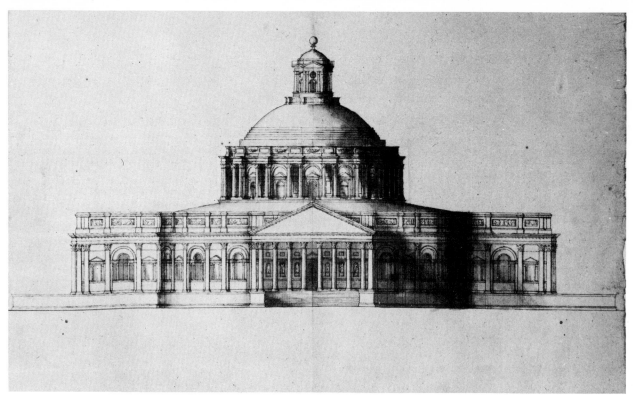

110 Elevation of a circular church with dome

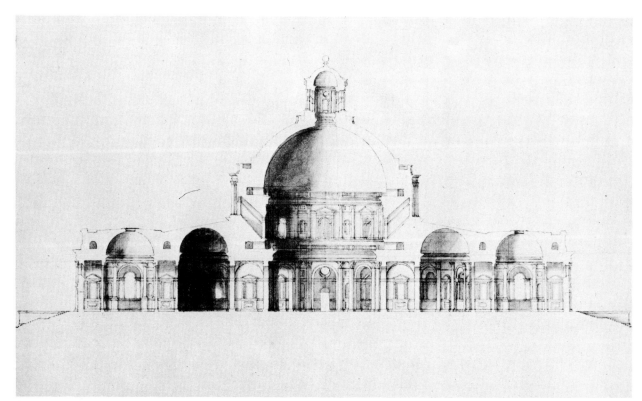

111 Section through a circular church with dome

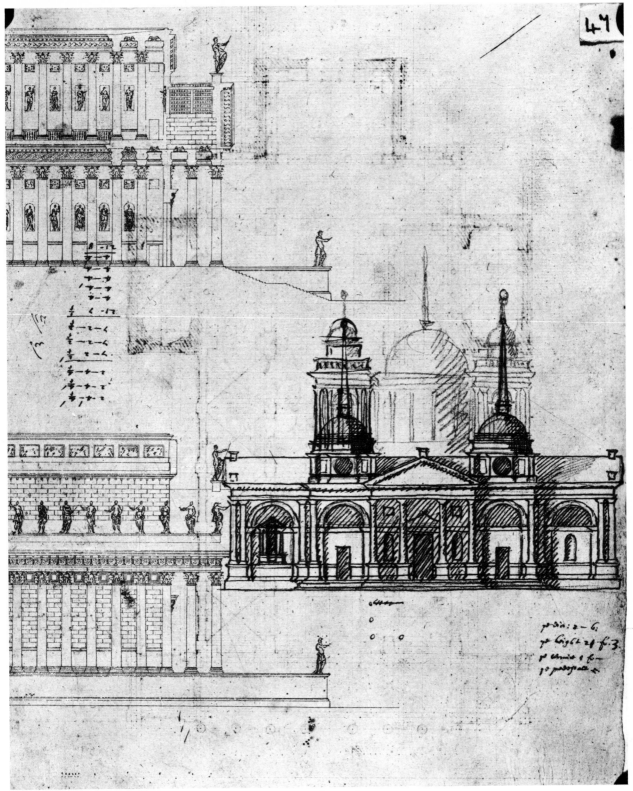

112 Elevation of a domed church and part elevation and section of a temple

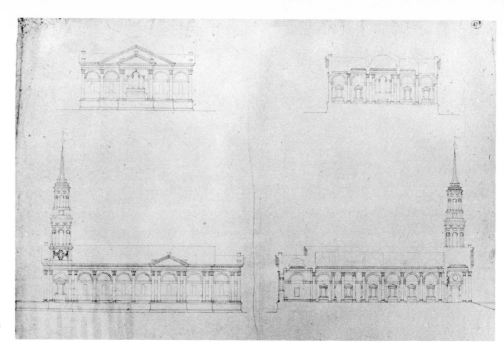

113 Elevations and
sections of a church
with campaniles

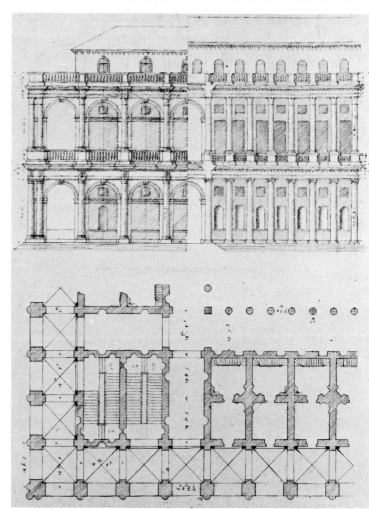

114 Sectional elevation
and part plan of a
Palladian basilica

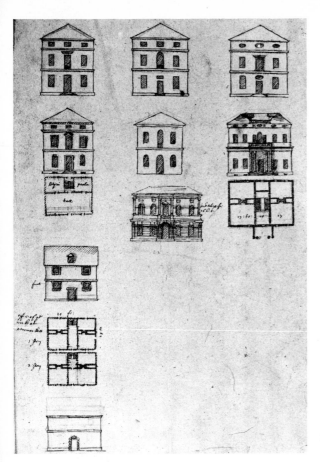

115 Plans and elevations
for small houses

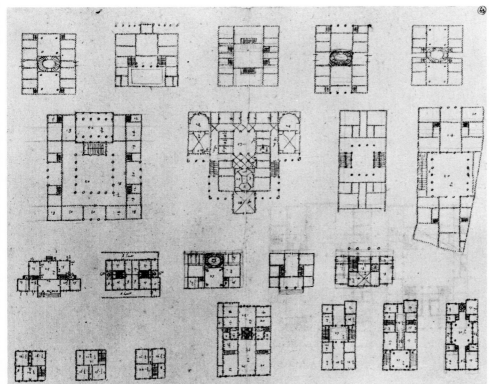

116 Twenty-one plans
for villas after
Palladio

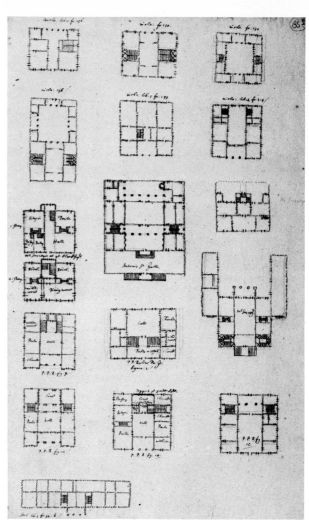

117 Twenty-five plans for villas and palaces. Right of the sheet only

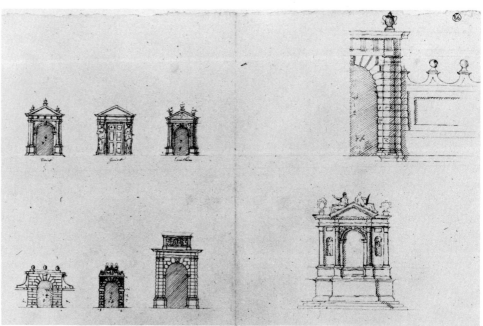

118 Eight drawings of arches, arcades, and their details

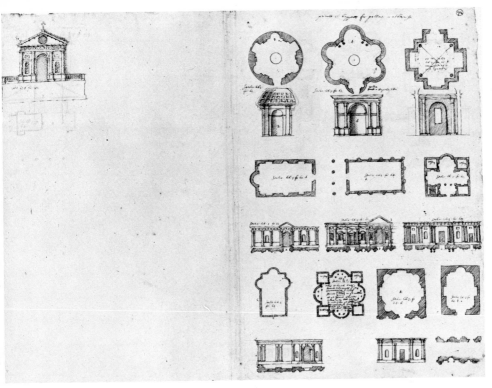

119 Eleven plans and nine elevations for small churches

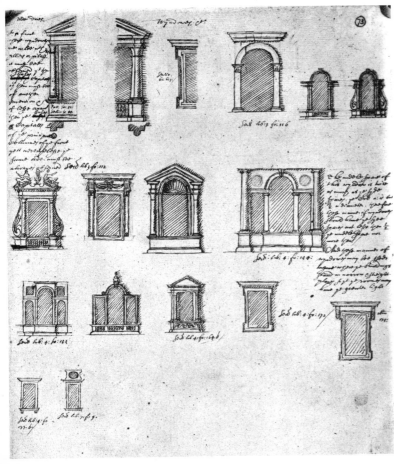

120 Seventeen elevations of windows and notes by John Webb

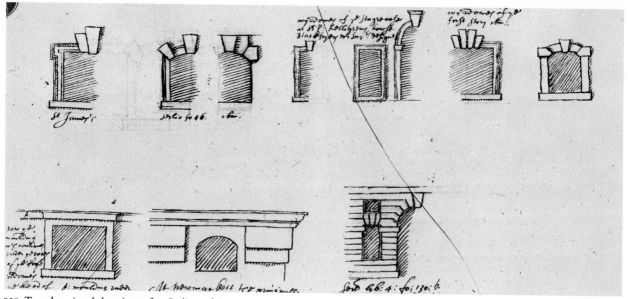

121 Ten elevational drawings after Serlio and Inigo Jones

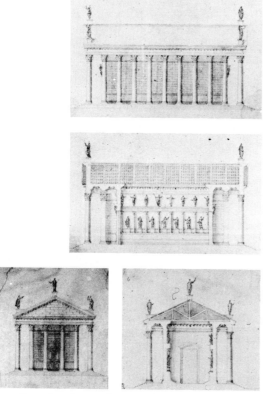

122 Two elevations and two sections through a peripheral temple

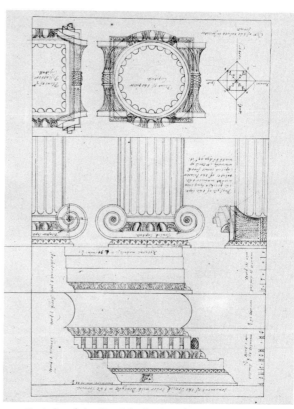

123 Capital and details of the Ionic order

124 Capital, architrave, frieze, and cornice of the Corinthian order

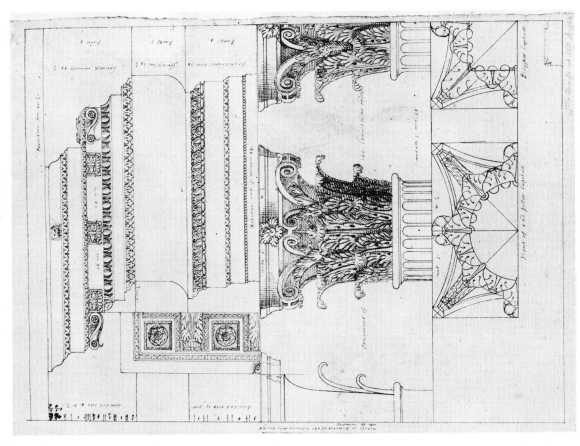

125 A page from Webb's manuscript 'of wyndowes'

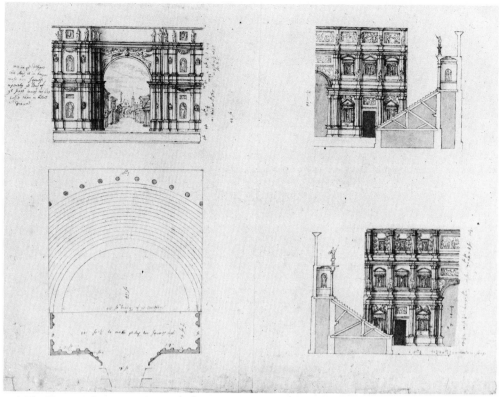

126 The Teatro Olimpico at Vicenza and Somerset House theatre

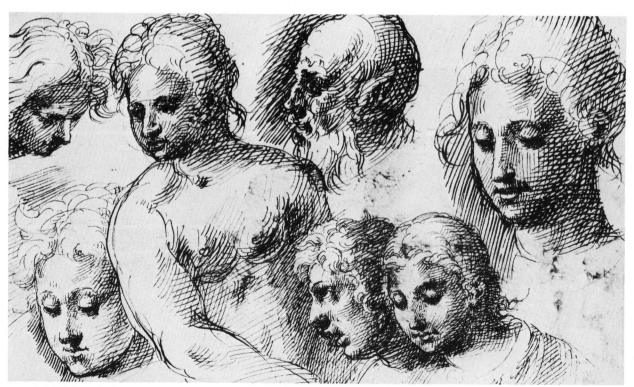

127 Sketch of seven heads by Inigo Jones